Rock over Barock

Young and Beautiful: 7

Ed

Wo

Thomas Kramer

Prinz Eisenbeton 6

SpringerWienNewYork | **Aedes**

Editors/Herausgeber: Wolf D. Prix, Thomas Kramer
Translation/Übersetzung: Dream Coordination Office (Lisa Rosenblatt & Charlotte Eckler)
Graphic Design and Typography/Grafische Gestaltung und Satz: Paulus M Dreibholz, London/Vienna
Printed by/Druck: Holzhausen Druck & Medien GmbH, 1140 Wien, Österreich

Rock over Barock is a touring exhibition hosted by AedesBerlin and framework.
Idea and concept/Idee und Konzept: Wolf D. Prix
Curator/Kurator: Reiner Zettl
Project management/Projektleitung: Hannes Stiefel, Katharina Müller
Animations/Animationen: Armin Hess, Daniel Kerbler

Printed on acid-free and chlorine-free bleached paper
Gedruckt auf säurefreiem, chlorfrei gebleichtem Papier — TCF

SPIN: 11605416
With numerous color illustrations
Mit zahlreichen farbigen Abbildungen

© 2006 Springer-Verlag/Wien
Printed in Austria
SpringerWienNewYork is a part of Springer Science + Business Media
www.springeronline.com

Bibliografische Information Der Deutschen Bibliothek
Die Deutsche Bibliothek verzeichnet diese Publikation in der Deutschen Nationalbibliografie;
detaillierte bibliografische Daten sind im Internet über http://dnb.ddb.de abrufbar.

ISBN-10 3-211-31028-2 SpringerWienNewYork
ISBN-13 987-3-211-31028-1 SpringerWienNewYork

Let's Rock over Barock
—Wolf D. Prix

The desire to celebrate space: based on 7 + 2 examples, the exhibition "Rock over Barock" at the Aedes gallery in Berlin will convey what could comprise a specific, shared, distinctive Austrian architecture. These young architects show that for all of their diversity, it is nonetheless possible to discover a distinct quality in Austrian architecture: the architecture of the spatial sequence.

Although architecture, too, must be thought of in global terms, it is becoming increasingly important to develop the unmistakable uniqueness of an authentic architectural language, one that can be defined only in the context of a cultural background. We can embark upon the attempt to define, through their cultural roots, the world's architects who determine the architectural discussion at the moment. We can call the Dutch and the Swiss, in contrast to the Austrian space inventors, strict "diagram Calvinists"; a Rietveld in Vienna is just as unthinkable as a Kiesler in Rotterdam. We can call Frank Gehry, Eric Moss, and Daniel Libeskind Cabbalists and mystically describe their architecture as powerfully literate and eloquent. And Zaha Hadid's designs are clearly the spatial signs of Arabic calligraphies.

Yet when searching for the uniqueness of Austria's architecture, we constantly stumble upon the missing theoretical foundation that would allow an interpretation and stylization of the architects' clearly evident qualities in such a way that a sharply contoured image appears of what might make Austrian architects distinguishable in the global scene: namely, the desire to redefine built space.

Although the lack of a supporting theory might open up individual possibilities, the often acclaimed diversity—perhaps otherwise a sign of strength—is ultimately just the sum of lone warriors, which opens the gates to international recognition for only very few Austrian architects.

Whereas in other countries, young architects learn to ride the slipstream of their land's greatest names, in Austria we practice patricide. However, this patricide is not an act of liberation: it is simply an unruly defiance of tradition, a reflection of Austria's anti-intellectual stance. This prevents a discursive confrontation with innovative architectural qualities that risk being novel.

What madness to build immensely heavy domes and have them vanish under heavenly visions! By taking the desire for spatial design evident in baroque structures as a starting point, a particular skill of Austrian architects becomes clear: designing complex space rather than the simplified box. From Fischer von Erlach to Rudolph M. Schindler and Friedrich Kiesler through to Hans Hollein, Walter Pichler, Raimund Abraham, Günther Domenig, and Coop Himmelb(l)au, these architects' buildings provide structural evidence that a formal language exists, which makes Austrian architecture unmistakable in the global scene.

Consciously or unconsciously, in ways appropriate to their era, young architects follow the baroque traces of spatial sequences—and change them. "Rock over Barock," with its 7+2 examples, shows that there is an Austrian tradition, as it were, which goes beyond the scattered battles of lone warriors: it is the shared desire to celebrate space.

Wolf D. Prix / Coop Himmelb(l)au is head of the Institute of Architecture at the University of Applied Arts Vienna and leads a design studio there.

Über die Lust, den Raum zu zelebrieren: Anhand von 7+2 Beispielen vermittelt die Ausstellung „Rock over Barock" in der Berliner Galerie Aedes, worin das spezifisch Gemeinsame, Unverwechselbare österreichischer Architektur bestehen könnte. Diese jungen Architektinnen und Architekten zeigen, dass bei aller Verschiedenartigkeit doch eine charakteristische Qualität in der österreichischen Architektur zu entdecken ist: die Architektur der Raumsequenz.

Obwohl auch in der Architektur global gedacht werden muss, wird es immer wichtiger, die unverwechselbare Eigenart einer authentischen Architektursprache, die sich nur im Zusammenhang mit einem kulturellen Hintergrund definieren lässt, zu entwickeln. Wir könnten den Versuch wagen, die Architekten der Welt, die momentan die Architekturdiskussion bestimmen, über ihre kulturellen Wurzeln zu beschreiben. Im Unterbewusstsein verankert, sind sie nicht zu verleugnen. Wir könnten die Holländer und Schweizer zur Unterscheidung von den österreichischen Raumerfindern strenge „Diagramm-Calvinisten" nennen, ein Rietveld in Wien ist genauso undenkbar wie ein Kiesler in Rotterdam. Wir könnten Frank Gehry, Eric Moss und Daniel Libeskind Kabbalisten nennen und ihre Architektur mystisch als buchstaben- und wortgewaltig beschreiben. Und Zaha Hadids Entwürfe sind eindeutig die räumlichen Zeichen arabischer Kalligrafien.

Auf der Suche nach der Einzigartigkeit österreichischer Baukunst stößt man immer wieder auf den fehlenden theoretischen Unterbau, der es erlauben würde, die zweifellos vorhandenen Qualitäten der Architekten so zu interpretieren und zu stilisieren, dass als Profil scharfkantig erscheint, was die österreichischen Architekten in der Weltszene unterscheidbar machen könnte: nämlich der Wille zur Neudefinition des gebauten Raumes.

Das Fehlen einer unterstützenden Theorie öffnet zwar den Weg individueller Möglichkeiten. Aber die so gepriesene Vielfalt – vielleicht sonst ein Zeichen von Stärke – ist dann letztlich oft nur die Summe von Einzelkämpfertum und öffnet nur ganz wenigen österreichischen Architekten die Türe zur internationalen Anerkennung.

Während in anderen Ländern junge Architekten lernen, im Windschatten der großen Namen ihres Landes herzufahren, wird bei uns in Österreich Vatermord praktiziert. Allerdings ist dieser Vatermord kein Akt der Befreiung, sondern nur renitenter Trotz gegenüber Tradition und spiegelt die anti-intellektuelle Haltung Österreichs. Wodurch die diskursive Auseinandersetzung mit innovativen Architekturqualitäten, die Neues wagen, verhindert wird.

Wenn man aber von der Lust an der Raumgestalt der Bauwerke des Barocks ausgeht – was für ein Wahnsinn, tonnenschwere Kuppeln zu bauen, um sie dann mit Himmelsmalereien zum Entschwinden zu bringen! – dann wird sichtbar, dass die Gestalt des komplexen Raumes und nicht die simplifizierte Box eine besondere Fähigkeit der österreichischen Architekten darstellt. Von Fischer von Erlach über Rudolph M. Schindler und Friedrich Kiesler bis zu Hans Hollein, Walter Pichler, Raimund Abraham, Günther Domenig und Coop Himmelb(l)au sind die Häuser dieser Architekten gebaute Beweise für die Existenz einer Formensprache, die die österreichische Architektur unverwechselbar in der Weltszene platziert.

Bewusst oder unbewusst folgen junge Architekten in ihrem Sinne zeitrichtig den barocken Spuren der Raumsequenzen – und verändern sie. „Rock over Barock" mit seinen 7 + 2 Beispielen zeigt, dass es doch eine österreichische, wenn man so will: Tradition gibt, die über verstreutes Einzelkämpfertum hinausgeht: eben die gemeinsame Lust, den Raum zu zelebrieren.

Wolf D. Prix / Coop Himmelb(l)au leitet das Institut für Architektur an der Universität für Angewandte Kunst Wien und führt dort ein Entwurfstudio.

When Is the Present?
—Kristin Feireiss and Hans-Jürgen Commerell

A constant updating of the definition of architecture in its theoretical and practical concerns as well as an examination of contemporary demands is at the core of architectural education at the Institute of Architecture of the University of Applied Arts Vienna.

It is therefore logical to ask: where do contemporary design, construction, and planning draw their stimulus from, and what should provide orientation—socially and historically—for today's architecture?

Baroque!?

Wolf D. Prix's thesis is brilliant. With "Rock over Barock" the institute does more than merely define a theoretical task. The "Angewandte" (University of Applied Arts) as a whole hereby also turns its focus outward. It asks: where does Austrian architecture, which we know is in the international vanguard, obtain its status and its quality?"

What does a twentieth century musical style have to do with a seventeenth century building style? Wolf D. Prix, chairman of the Institute of Architecture at the "Angewandte" has managed to bridge the gap spanning the centuries. "Baroque's desire for spatial design" and the power of a new generation of Austrian architects make explicit what Prix sees as differentiating the architects of the Alpine republic from other architects: "the desire to redefine built space."

The members of the Rock over Barock orchestra, who make their appearance with curator Reiner Zettl as conductor—ARTEC Architekten, Urs Bette, Delugan Meissl Associated Architects, Sophie Grell, stiefel kramer, Klaus Stattmann, Tercer Piso Arquitectos, the next ENTERprise architects, and Wolfgang Tschapeller—form the cross section of Austria's avant-garde. Many are graduates of the University of Applied Arts Vienna and former members of Wolf Prix's Master Class. The statement by philosopher Vladimir Jankélévitch: "At first there is always adventure," can be applied to Wolf Prix and his students. In this case, the adventure in the celebration of space.

Die stetige Aktualisierung der Definition von Architektur in ihren theoretischen wie praktischen Belangen sowie die Überprüfung im Hinblick auf zeitgenössische Anforderungen ist Kern der Architekturausbildung des Institutes für Architektur an der Universität für Angewandte Kunst Wien.

Die Frage also, woraus bezieht gegenwärtiges Entwerfen, Gestalten und Planen seine Impulse und woran soll sich heutige Architektur gesellschaftlich wie geschichtlich orientieren, ist folgerichtig.

Aus dem Barock!?

Wolf D. Prix' These ist genial. Das Institut stellt mit „Rock over Barock" damit nicht nur eine theoretische Arbeitsaufgabe. Die „Angewandte" als Ganzes richtet sich damit auch nach außen mit der Frage, woraus österreichische Architektur, die, wie wir wissen, international führend ist, ihren Status und Ihre Qualität bezieht.

Eine Musikrichtung des 20. Jahrhunderts und ein Baustil des 17. Jahrhunderts – wie geht das zusammen? Wolf D. Prix, Vorstand des Instituts für Architektur an der Angewandten, ist der Spagat über die Jahrhunderte hinweg gelungen: „Die Lust an der Raumgestalt des Barocks" und die Kraft einer neuen österreichischen Architektengeneration macht deutlich, was – so Prix – die Architekten des Alpenlandes von anderen unterscheidet: „der Wille zur Neudefinition des gebauten Raumes".

Alle Spieler des „Rock over Barock"-Orchesters, die, vom Kurator Reiner Zettl dirigiert, in dieser Ausstellung auftreten – ARTEC, Urs Bette, Delugan Meissl Associated Architects, Sophie Grell, stiefel kramer, Klaus Stattmann, Tercer Piso Arquitectos, the next ENTERprise und Wolfgang Tschapeller –, bilden den Querschnitt der österreichischen Architektur-Avantgarde. Viele von ihnen waren Absolventen der Hochschule für Angewandte Kunst Wien und Meisterschüler von Wolf D. Prix, für den und seine Studenten gilt, was der französische Philosoph Vladimir Jankélévitch in dem Satz formuliert: "Am Anfang steht immer das Abenteuer". In diesem Fall das Abenteuer Raum.

Rock over Barock
—Reiner Zettl

Raimund Abraham Metropolitan Core, 1963/64

Johannes Kepler was still in Prague in 1609 when his Astronomia Nova was published, yet he would arrive in the Austrian city of Linz three years later where he would work as a mathematician until 1626. For this information I am grateful to the American architecture theorist Jeffrey Kipnis. At times I have the pleasure of working with him, and on one of these occasions we went through several of the connections—outlined briefly here—between the natural sciences, architectural theory, and music.

The relationship between musical harmony and architectural proportion was one of the bases of Renaissance architectural theory. Simple relations of numbers guaranteed both architecture's beauty and music's euphony. This fascinating correspondence of pure reason and emotion is what made up the Renaissance world. Yet this harmony fell apart when empirical natural sciences accumulated too many facts that did not fit seamlessly into the scheme. If we assume that Baroque was the answer to the crisis and ultimate collapse of the Renaissance's static ideas of order in Mannerism, then the dynamic form of cosmic relations in Kepler's heavenly music signifies a crucial step along this path toward the reformulation of relations. Kepler's discovery of the Laws of Planetary Motion transformed the medieval picture of the world, which was characterized by concentric circles, into a new system in which the sun actively influenced the planets through its gravitational attraction. The spherical cosmos thus distorted to become an elliptical reference system of energies. Movement was also the driving force behind the reformulation of spatial qualities in architecture. What no longer rested at the center necessarily became distorted in the directions of the orbits that traverse space. Parallel to that, in view of the material shell of space, the interest in an emphasis on linear structural elements originating in classical antiquity shifted to the staging of bent surfaces with an increasingly complex geometry of diverse relations. At the end of this development, Francesco Borromini conceived sequences of inter-penetrating spaces, whose incomplete figures beholders had to reconstruct.

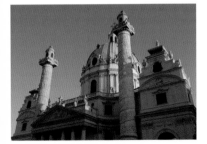

Johann Bernhard Fischer von Erlach
Karlskirche, 1716–1737

"Rock over Barock" deals with a coming of age. The exhibition title also echoes music's battle call for independence: In 1956, Chuck Berry wrote the song "Roll over Beethoven," to finally capture his own space denied him by his sister Lucy's constant practicing of classical music on the family's piano. "And tell Tchaikovsky the news," he added to make it clear that the times had changed.

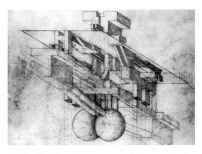

Walter Pichler Kern einer unterirdischen Stadt, 1963

When Brian Jones introduced the songs of Robert Johnson to his friend and band mate Keith Richards, Richards was so impressed by Johnson's walking bass that he asked, "Who's the other guy playing with him?" The Rolling Stones took this musically very sophisticated style and transformed the Delta Blues, the music of the social outcasts from the U.S.'s Deep South, into what we have learned to call Rock: a music that believes in the immediacy of expression. Sensing some sort of affinity, they helped themselves to a tradition that was not their own, to emancipate themselves from a social situation that they did not consider their own world. They also produced a version of "Roll over Beethoven," which appeared on the album **The Rolling Stones, Now!** in 1965.

A group of young architects and architecture students in Vienna, likewise dissatisfied with what they consider the dispassionate and petty state of their surroundings, adopted this attitude. They attempted to translate into their work the intensity of the stage presence of the rock stars they admired. In restaging public space, they also relied equally on baroque performance practices. They discovered the spark in their own past, as it were. The "Supersommer" organized by Coop Himmelblau in 1976 demonstrated the dramatic potential of urban spaces. Coop Himmelblau's Great Cloud Stage was like the arch of triumph for all who intended to playfully appropriate the city.

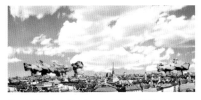

Hans Hollein Überbauung Wien, 1960

At the awakening of great events and emotions were forerunners such as the unfathomable—endless—sculptural visions of Friedrich Kiesler, who was two generations older, or fellow emigrant Rudolph M. Schindler. Schindler, in his 1934 essay "Space Architecture," wrote how he had long ago discovered—by stepping out of a farmhouse and gazing at the summer sky—the new medium of architecture: space.

Hans Hollein, Walter Pichler, Günther Domenig, Raimund Abraham, Haus-Rucker, and Coop Himmelblau, to name but a few, conceived immense urban nodes, whose spatial complexity recalls Piranesi, and in their collages, confronted conventional ideas of urban and rural with objects in a scale exceeding the ordinary. Similar to baroque ceiling frescoes, the heavens alone seem to provide the border.

A generation later, fully conscious of the ability to realize the utopias of the 1960s by virtue of the digital revolution, the exhibition "Rock over Barock" asks about the specific reference to Baroque in the work of young architects. In a space for Zita Kern, ARTEC builds a baroque Belvedere over the "nature" of the rough stonework of a farmhouse, which according to the stage theory of a baroque palace, is uncivilized. DELUGAN MEISSL demonstrates a similar

ennoblement of everyday reality with House Ray 1. Spatial diversity shines from an inconspicuous office building and stages the urban space at such great distances, that it replaces ceiling painting, as it were.

With their bath in Caldaro/Kaltern, the next ENTERprise architects create a bath over the lake in which the heavens are reflected, as though an outside fresco. They pierce this surface with two cliffs that open up inside to form grottos.

With the project "The dragon in the sea," Urs Bette enjoys creating artificial cliffs to grant eternal life, as it were, to an island in the Pacific, whose disappearance is being prevented for sound economic reasons. And in "Memento mori," stiefel kramer let a theater disappear into a tar pit as a performance of itself. With Kinsky House, Klaus Stattmann builds a building that, disguised as a tree, convinces the authorities of its invisibility to then turn out to be an alien. In Wolfgang Tschapeller's project BVA, one notices in a building opposite the historical city center, the history of the city in new organs of comprehensive sensuousness. With her canopy, Sophie Grell syncopates the rhythm of the baroque court mews to make the invisible MuseumsQuartier noticeable, and Tercer Piso Arquitectos builds a roof in Mexico, whose geometry comprises a multitude of figures and precisely through this complexity, converges with the surroundings.

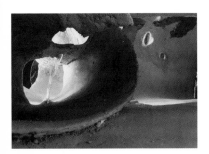

Friedrich Kiesler Endless House, 1959

Perhaps the answer can be grasped as follows:
Asked about his use of African music, especially its polyrhythmic element, Miles Davis answered, with a grin:
"There is just some stuff you got to be born into."

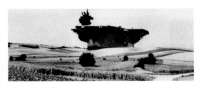

Hans Hollein Flugzeugträger in der Landschaft, 1964

Johannes Kepler war zwar noch in Prag, als 1609 seine „Astronomia Nova" erschien, aber er sollte schon drei Jahre später nach Linz kommen, wo er als Mathematiker bis 1626 wirkte. Ich verdanke diesen Hinweis dem amerikanischen Architekturtheoretiker Jeffrey Kipnis, mit dem ich ab und zu das Vergnügen der Zusammenarbeit habe, und bei einer dieser Gelegenheiten durchliefen wir einige der hier kurz angerissenen Zusammenhänge zwischen Naturwissenschaften, Architekturtheorie und Musik.

Die Beziehung zwischen musikalischer Harmonie und architektonischer Proportion war eine der Grundlagen der Architekturtheorie der Renaissance. Einfache Zahlenverhältnisse garantierten sowohl die Schönheit in der Architektur als auch den Wohlklang in der Musik. Das war die faszinierende

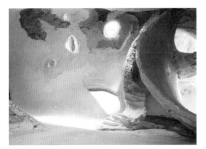

Friedrich Kiesler Endless House, 1959

Übereinstimmung von Ratio und Emotion, aus der heraus die Welt konstruiert wurde. Doch diese Harmonie zerbrach, da die empirischen Naturwissenschaften zu viele Fakten akkumulierten, die sich nicht bruchlos in das Schema einfügen ließen. Wenn wir annehmen, dass der Barock die Antwort auf die Krise und den letztendlichen Zusammenbruch der statischen Ordnungsvorstellungen der Renaissance im Manierismus waren, dann bedeutet die dynamische Fassung der kosmischen Verhältnisse in Keplers himmlischer Musik einen wesentlichen Schritt auf diesem Weg der Neuformulierung der Verhältnisse. Keplers Entdeckung der drei Planetengesetze transformierte das mittelalterliche, von konzentrischen Kreisen geprägte Weltbild in ein neues System, in dem die Sonne die Planeten durch Anziehung aktiv beeinflusst. Der kugelschalige Kosmos verformt sich dabei zu einem elliptischen Bezugssystem von Kräften.

Bewegung war auch die treibende Kraft hinter der Neuformulierung räum-licher Qualitäten in der Architektur. Was nicht mehr im Mittelpunkt ruhte, verformte sich notwendigerweise in den Richtungen der Ströme, die den Raum durchqueren. Parallel dazu verschob sich in der Sicht auf das materielle Gehäuse des Raumes das Interesse von einer Betonung linearer Strukturelemente klassisch antiker Provenienz auf die Inszenierung von gekrümmten Flächen mit einer zunehmend komplexer werdenden Geometrie der Beziehungsvielfalt. Am Ende dieser Entwicklung werden bei Francesco Borromini Sequenzen von einander durchdringenden Räumen konzipiert, deren unvollkommen gelassene Figuren vom Betrachter nachvollzogen werden müssen.

„Rock over Barock" handelt von Mündigkeit. Im Titel der Ausstellung klingt der Schlachtruf nach musikalischer Eigenständigkeit schlechthin nach: 1956 schrieb Chuck Berry den Song „Roll over Beethoven", um sich endlich seinen eigenen Raum zu erobern, den ihm seine Schwester Lucy durch ihr ständiges Üben klassischer Musik auf dem Familienklavier streitig gemacht hatte. „And tell Tchaikovsky the news", fügte er hinzu, um klar zu machen, dass sich die Zeiten nun geändert hätten.

Als Brian Jones seinen Freund Keith Richards, der in der gleichen Band spielte, mit Songs von Robert Johnson bekannt machte, war der von dessen Walking Bass so beeindruckt, dass er fragte, wer denn der zweite Gitarrist sei. Die Rolling Stones nahmen diesen musikalisch sehr anspruchsvollen Stil auf und verwandelten den Delta Blues, die Musik der Außenseiter aus dem Süden der Vereinigten Staaten, in das, was wir gelernt haben Rock zu nennen: eine Musik, die an die Unmittelbarkeit des Ausdrucks glaubt. In einer Art von Wahlverwandtschaft bedienten sie sich einer Tradition, die nicht die ihre war, um sich von

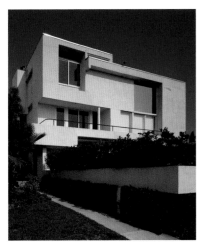

Rudolph M. Schindler Pearl Mackey House, 1939

einer gesellschaftlichen Situation zu emanzipieren, die sie nicht als eigene Welt betrachteten. Sie produzierten auch eine Fassung von „Roll over Beethoven", die 1965 auf „The Rolling Stones, Now!" erschien.

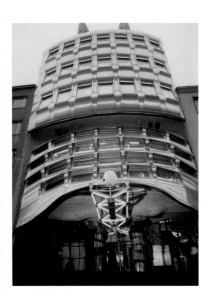

Günther Domenig ZBank, 1979

Eine Gruppe junger Architektinnen und Architekten und Studierender der Architektur in Wien, ebenso unzufrieden mit der als leidenschaftslose Kleinlichkeit gesehenen Verfassung ihrer Umgebung, nahm diese Haltung auf. Sie versuchten, die Intensität der Bühnenpräsenz der bewunderten Rockstars in ihrer Arbeit umzusetzen. In einer Neuinszenierung des öffentlichen Raumes griffen sie dabei aber gleichermaßen auch auf barocke Aufführungspraktiken zurück. Sie entdeckten gleichsam den Zündstoff in der eigenen Vergangenheit. Der 1976 von Coop Himmelblau veranstaltete „Supersommer" führte das dramatische Potential städtischer Räume vor. Ihre „Große Wolkenkulisse" war dabei so etwas wie das Triumphtor für all jene, die sich spielerisch die Stadt aneignen wollten.
Man fand im Aufbruch zu großen Erlebnissen und Emotionen Vorläufer wie die unauslotbaren – endlosen – plastischen Visionen des zwei Generationen älteren Friedrich Kiesler oder den ebenso emigrierten Rudolph M. Schindler, der in seinem Aufsatz „Space Architecture" von 1934 beschrieb, wie er, vor langer Zeit aus einem Bauernhaus tretend, in einem Blick zum Sommerhimmel das neue Medium der Architektur entdeckt hatte: den Raum.
Hans Hollein, Walter Pichler, Günther Domenig, Raimund Abraham, die Haus-Rucker und Coop Himmelblau, um nur eine Auswahl zu nennen, konzipieren riesige Stadtknoten, deren räumliche Komplexität an Piranesi erinnert, und konfrontieren in ihren Collagen konventionelle Vorstellungen von Stadt und Landschaft mit Objekten in einem Maßstab jenseits des Gewöhnlichen. Wie in barocken Deckenfresken scheint dabei nur der Himmel die Grenze zu sein.

Eine Generation später – im Bewusstsein, aufgrund der digitalen Revolution die Utopien der 60er-Jahre verwirklichen zu können – stellt die Ausstellung „Rock over Barock" die Frage, wie die Arbeiten junger Architektinnen und Architekten spezifisch auf den Barock Bezug nehmen.
ARTEC baut im Raum für Zita Kern ein barockes Belvedere über der – gemäß der Stufentheorie eines Barockpalais unzivilisierten – Natur des rohen Mauerwerks eines Bauernhofes. DELUGAN MEISSL führen eine ähnliche Veredelung alltäglicher Realität in ihrem Haus Ray 1 vor. Auf einem unscheinbaren Bürogebäude glänzt räumliche Vielfalt und inszeniert den städtischen Raum in einer Weite, die gleichsam die Deckenmalerei ersetzt.

the next ENTERprise architects kreieren in ihrem Seebad in Kaltern ein Becken über dem See, in dem sich der Himmel spiegelt, als wäre es ein außenliegendes Fresko, und durchstoßen diese Fläche mit zwei Felsen, die sich innen zu Grotten öffnen.

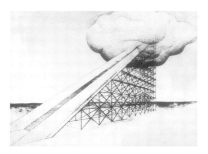

Haus-Rucker Big Piano, 1972

Im Vergnügen, künstlichen Fels zu erzeugen, gibt Urs Bette im Projekt „The dragon in the sea" einer Insel im Pazifik, die aus ganz handfesten ökonomischen Gründen nicht verschwinden darf, sozusagen ewiges Leben, und stiefel kramer lassen bei „Memento mori" ein Theater als seine eigene Aufführung in einem Teersumpf verschwinden. Klaus Stattmann baut mit dem Haus Kinsky ein Gebäude, das als Baum getarnt die Behörden von seiner Unsichtbarkeit überzeugt, um sich dann als Alien zu entpuppen. Bei Wolfgang Tschapeller spürt man im Projekt BVA in einem Gebäude gegenüber der historischen Innenstadt die Geschichte der Stadt in neuen Organen einer umfassenden Sinnlichkeit. Sophie Grell synkopiert in ihrem Vordach den Rhythmus der Fassade der barocken Hofstallungen, um das unsichtbare MuseumsQuartier spürbar werden zu lassen, und Tercer Piso Arquitectos bauen in Mexiko ein Dach, dessen Geometrie aus einer Vielzahl von Figuren besteht und gerade in dieser Komplexität sich der Umgebung annähert.

Vielleicht lässt sich die Antwort so fassen:
Angesprochen auf seine Verwendung afrikanischer Musik, vor allem in ihrer Polyrhythmik, antwortete Miles Davis grinsend:
„There is just some stuff you got to be born into."

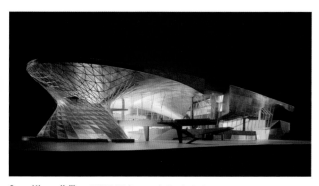

Coop Himmelb(l)au BMW Welt, completion in 2006

ARTEC Architekten

ARTEC Architekten was founded in Vienna in 1985. The office consists of Bettina Götz and Richard Manahl. They studied at the University of Technology Graz: Bettina Götz 1980–1987, Richard Manahl 1973–1982; and both have taught at various times at the University of Technology Vienna. They have realized projects of various magnitudes throughout Austria; these have been publicized and exhibited internationally. In 2005 ARTEC Architekten received the Preis der Stadt Wien and two nominations for the Mies van der Rohe Prize (Efaflex was under the selected works and Apotheke Aspern was nominated): www.artec-architekten.at

Wood house in Bocksdorf, Burgenland, Austria, 2005
Residential home in Alxingergasse, Vienna, Austria, 2002–2004
Residential and commercial building Scheffelstrasse in Bregenz, Vorarlberg, Austria, 2002–2004
Residential building at Hundsturmpark, 28 apartments, Vienna, Austria, 1999–2004
Company buildings for the firm Efaflex in Baden, Lower Austria, 2002–2004
Apotheke zum Löwen von Aspern, Vienna, Austria, 2002–2003
Power plant Felsenau, expert appraisal 2000, competition—first prize, Feldkirch, Austria, 2000–2003
Residential building and sports complex on Wiedner Hauptstrasse, Vienna, Austria, 1998–2003
Residential development Laxenburgerstrasse, 404 apartments, competition—first prize, Vienna, Austria, 1998–2001
Kreuz-Apotheke in Peuerbach, Upper Austria, 1998–1999
Raum Zita Kern, Addition and reconstruction of a farmhouse in Marchfeld, Raasdorf, Lower Austria, 1996–1998
Main Library and diverse additions and reconstructions at the provincial high court Graz, Austria, 1995–1998, 1999–2003
Kunstraum Wien, later "Depot," MuseumsQuartier, Fischer-Trakt, Vienna, Austria, 1994/1997
Zehdengasse School, thirteen-room elementary school, Vienna, Austria, 1993–1996
"Der zerbrochene Spiegel," exhibition architecture, MuseumsQuartier and Kunsthalle Wien, Vienna, Austria, 1993
Residential buildings in Bärnbach, 39 apartments, competition—first prize, Styria, Austria, 1992–1998
Office building in Bludenz, Vorarlberg, Austria, 1990–1993
Town houses on Weiherweg, Nüziders, Vorarlberg, Austria, 1989–1994
Residential building in Nüziders, Vorarlberg, Austria, 1986–1989

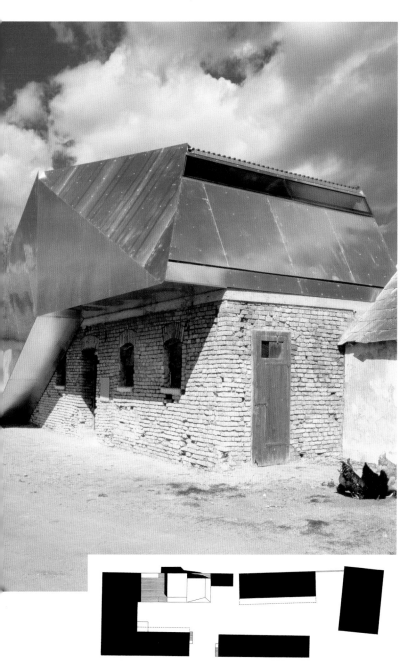

Raum Zita Kern
Raasdorf, Lower Austria
1996–1998

A world of its own on the flat land before Vienna.

Zita Kern is a farmer and literary scholar.

Working spaces of the farm are available; missing are a room for bathing and space to write.

The old building structure sets the framework:

The area of the old storeroom becomes a large, introverted bathroom; the removal of a few beams allows for natural lighting from above.

The added and attached volume of building output gains its form from the marginal conditions: opening to terrace, entrance and stairway without intervening in the structure, and the figure's transition to the small house of the chicken coop.

The new element in the yard ensemble shows itself as unambiguously new: the sheer aluminum body absorbs the mood of the weather and surroundings. The building becomes immaterial, its purpose obscured. The inside form of the addition is more like a tent than a permanent building. The furnishings are part of the wall and at the same time a possibility for structuring the space. Light incidence and openings do not have an immediate relationship with the yard.

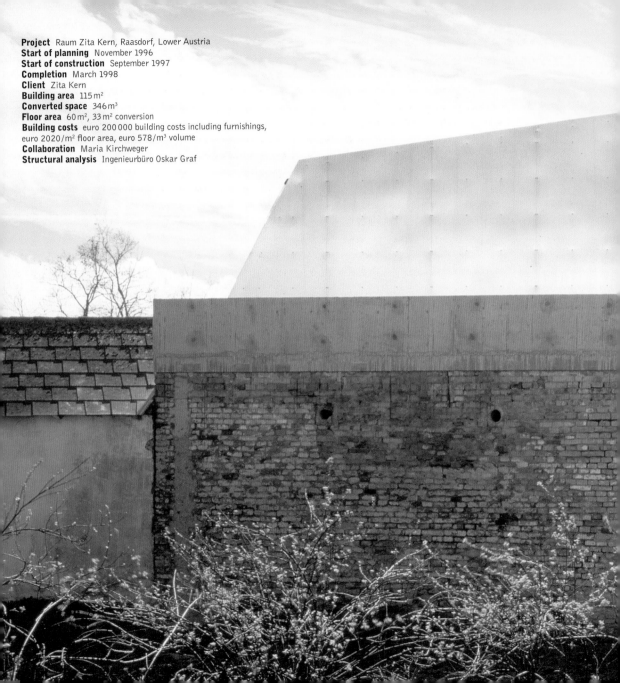

Project Raum Zita Kern, Raasdorf, Lower Austria
Start of planning November 1996
Start of construction September 1997
Completion March 1998
Client Zita Kern
Building area 115 m²
Converted space 346 m³
Floor area 60 m², 33 m² conversion
Building costs euro 200 000 building costs including furnishings,
euro 2020/m² floor area, euro 578/m³ volume
Collaboration Maria Kirchweger
Structural analysis Ingenieurbüro Oskar Graf

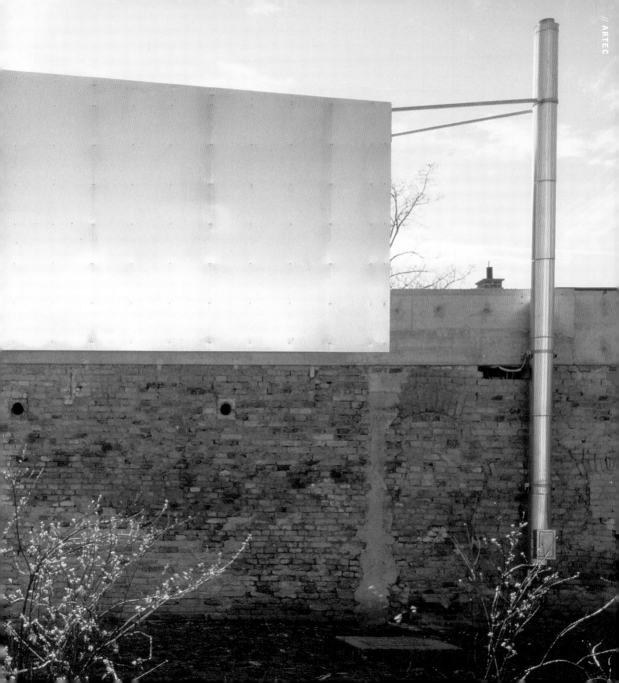

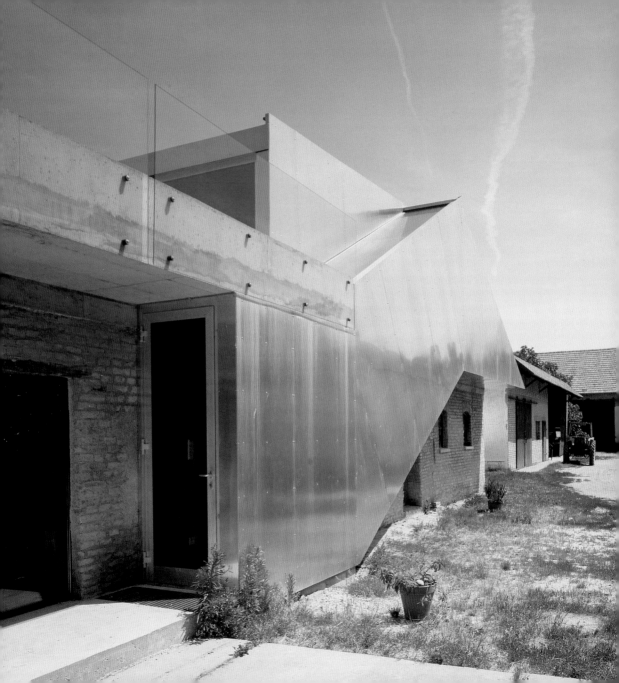

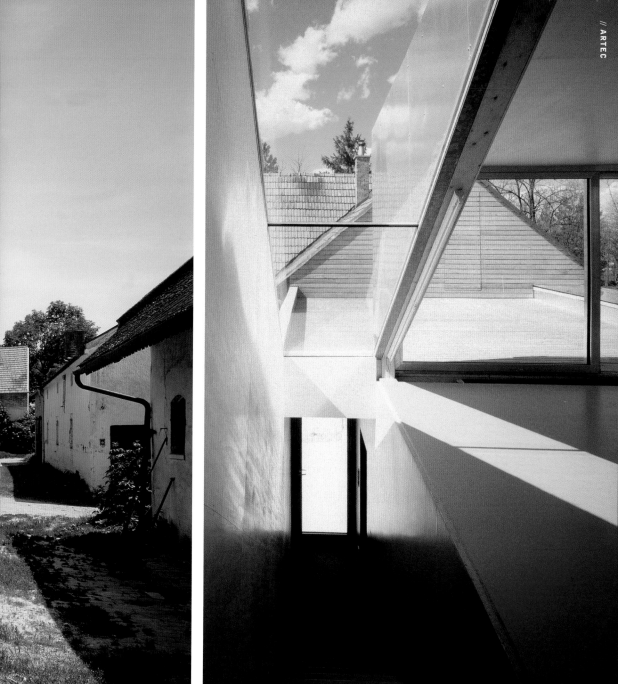

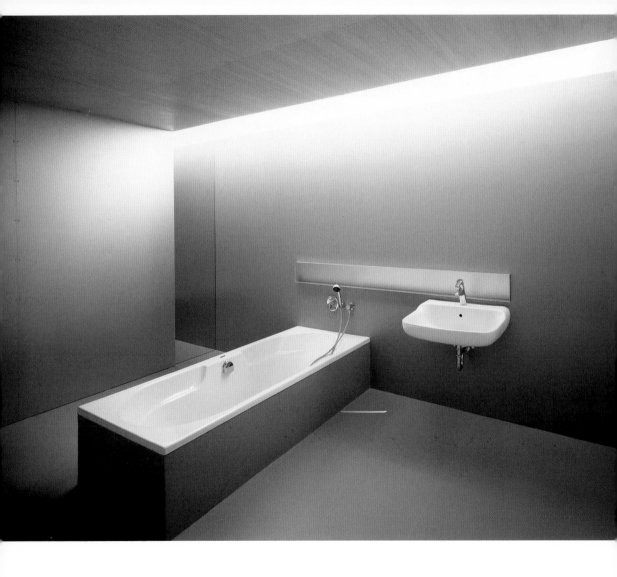

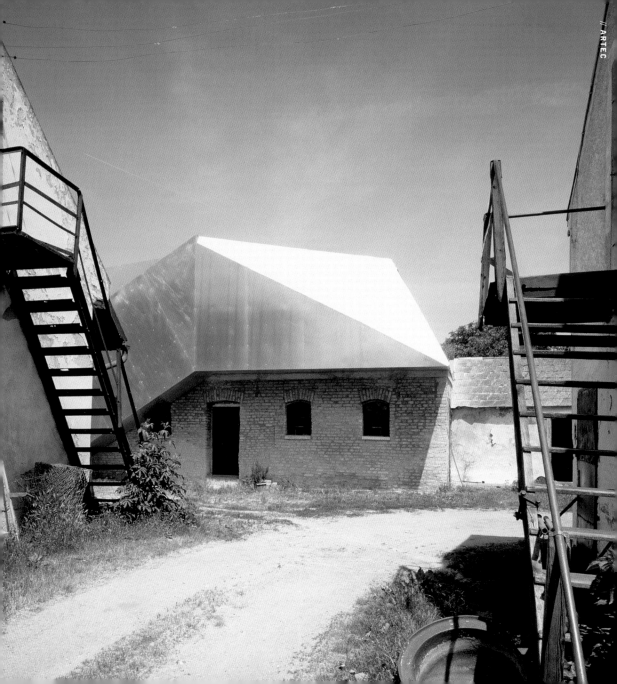

Apotheke zum Löwen von Aspern
Vienna, Austria
2002–2003

The space is developed as a thoroughly transparent spatial sequence through a closed building block.

A broad, concrete ceiling stretches like a magic carpet over the open space, forming a connection to the adjacent streets through the upward slope of the ends on the street sides.

Courtyards carry through the building substance.

The sales floor is structured by "ribbons of light," set flush into the ceiling. Where the ribbons swell into the room, they form shelves.

Start of planning October 2002
Start of construction April 2003
Completion September 2003
Client Dr. Wilhelm Schlagintweit KG / PHOENIX Arzneiwaren GmbH, Vienna
Surface area 643 m², 446 m²
Converted space 2500 m³
Gross floor area 581 m²
Floor area 487 m²
Building costs euro 1 000 000 including all furnishings, euro 2053/m² floor area, euro 400/m³ volume
Collaboration Ronald Mikolics (construction), Irene Prieler (furnishings), Ivan Zdenkovic / Wolfgang Beyer (CAD visualization), Julia Beer (model)
Structure, building physics Ingenieurbüro Oskar Graf
Planning of building technology Ingenieurbüro Christian Koppensteiner
General planning ARTEC Architekten and Ingenieurbüro Oskar Graf
Landscaping D.I.Jakob Fina, Vienna

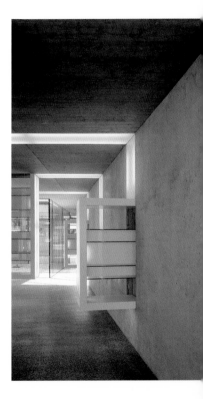

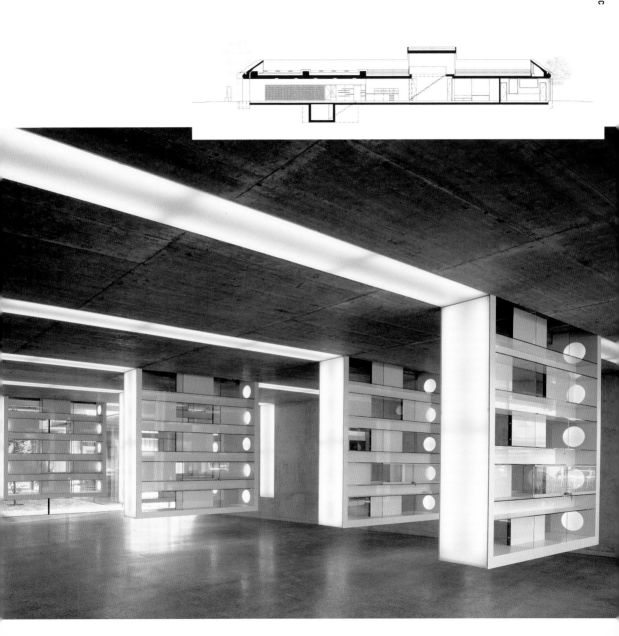

Balic-Benzing House
Bocksdorf, Burgenland, Austria
2004–2005

Southern Burgenland is a landscape of gently rolling hills.

The building site spans over a knoll with a magnificent view stretching far into Styria.

The spatial demands are modest:
A room for the owner (60 m²), and a smaller room for guests, separated by an interstitial space that can be regulated with sliding doors.

The terrace creates a sense of composure and grand scale:
Two levels, 29 × 8 m each, form the floor and roof. The terraces make it possible to be outdoors, protected from the weather, up, over the slope.

Project Hilltop vacation home, Bocksdorf bei Güssing, Burgenland
Start of planning July 2004
Completion Autumn 2005
Client Dr. Renate Balic-Benzing and Emin Balic-Tahir, Vienna
Surface area 14 435 m²
Building area 223 m²
Converted space 420 m³
Gross floor area 127 m²
Floor area 86 + 14 m²
Collaboration Ronald Mikolics, Julia Beer (model)
Structural analysis Peter Bauer, werkraum wien – ingenieure

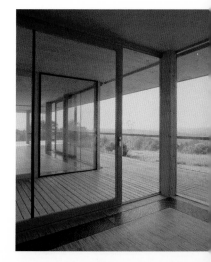

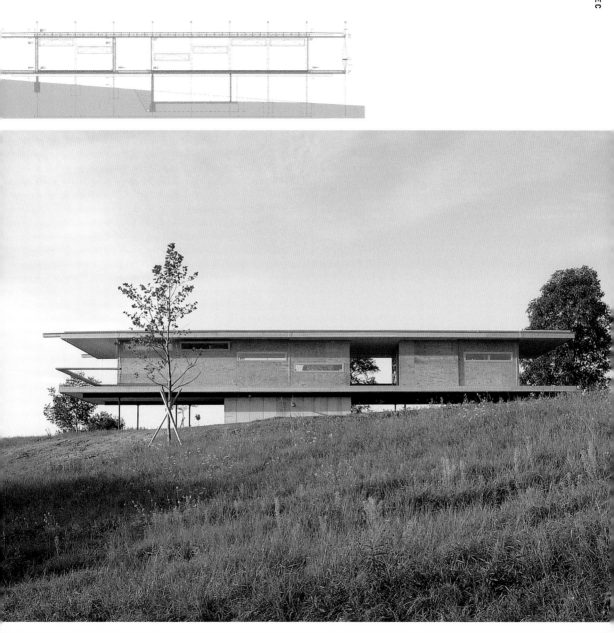

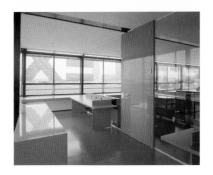

Efaflex Torsysteme
Baden, Lower Austria
2003–2004

The new structure ends up in the middle of a field.

The unspecific property allows the building to develop from its own content:

The hall is at ground level; the office area develops from a generously covered entrance through an entrance area with a view and a space for meetings, to the upper level.

A skin of metallic paneling surrounds the body of the structure; office area and entrance are distinguished by flush surface glazing.

Project Service building in Baden, Lower Austria
Start of planning December 2002
Start of construction September 2003
Completion March 2004
Client Efaflex Torsysteme, Ferdinand Türtscher, Baden, Lower Austria
Surface area 2121 m²
Building area 445 m²
Converted space 3650 m³
Gross floor area 708 m²
Floor area 639 m²
Building costs euro 600 000 building costs including office furnishings, euro 938/m² floor area (incl. office furnishings), euro 164/m³ volume (incl. office furnishings)
Collaboration D.I. Irene Prieler, Arch.D.I. Ivan Zdenkovic (CAD visualization), Julia Beer (model)
Structural analysis, building physics Ingenieurbüro Oskar Graf, Vienna
Installation planning Ingenieurbüro Christian Koppensteiner, Vienna
General planning ARTEC Architekten and Ingenieurbüro Oskar Graf, Vienna

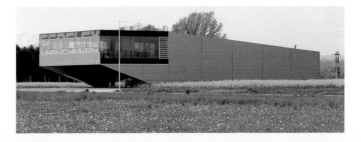

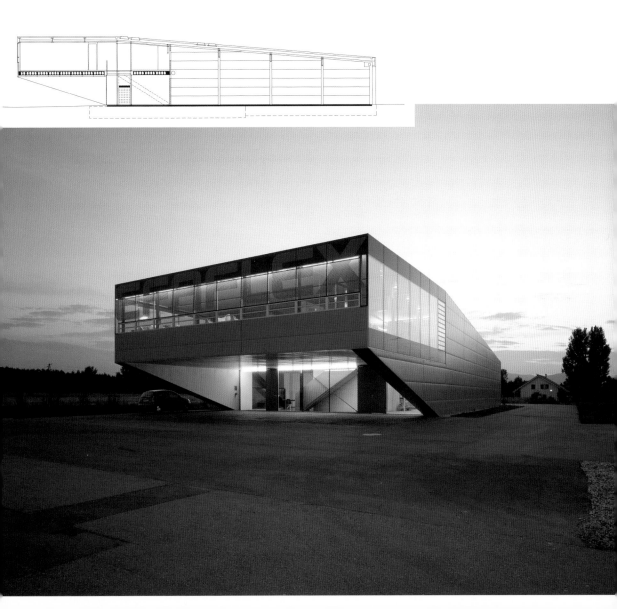

Urs Bette

Urs Bette graduated with a degree in Visual Communication Design from the Academy of Applied Sciences, Düsseldorf in 1992. In 2000, he received his Diploma in Architecture from the Master Class of Wolf D. Prix, University of Applied Arts Vienna. Since 1997, he has had his own office in Vienna. The Austrian Federal Chancellery, Arts Section, Vienna awarded him a scholarship in 1999 and he received an honorable mention for the Austrian Federal Award for Experimental Architecture in 2000. Exhibitions: "12 écoles d'architecture en Europe," FRAC Centre, Orléans, France, 2001; "The dragon in the sea," Arch + Journal for architecture and city planning, Aachen, Germany, 2001; "Moving Out," University of Applied Arts Vienna, Museum of Modern Art— Stiftung Ludwig, Vienna, Austria, 2002; "Reserve of Form," Künstlerhaus, Vienna, Austria, 2004. www.bette.at

Suzuki House Extension Tokyo, Japan, 1995
prêt-à-porter competition—second prize, Vienna, Austria, 1996
Amevor House and Hotel project (with Hannes Stiefel), Ho, Ghana, 1997
entries & exits city planning project, Vienna, Austria, 1997
The flat as answering machine Vienna, Austria, 1997
The dragon in the sea Okinotorishima, Japan, 2000
Zazie—cinema and bar (with Andreas Haase) Halle, Germany, 2001
Uralla Court Adelaide, Australia, 2003
Uralla Court II Adelaide, Australia, 2005

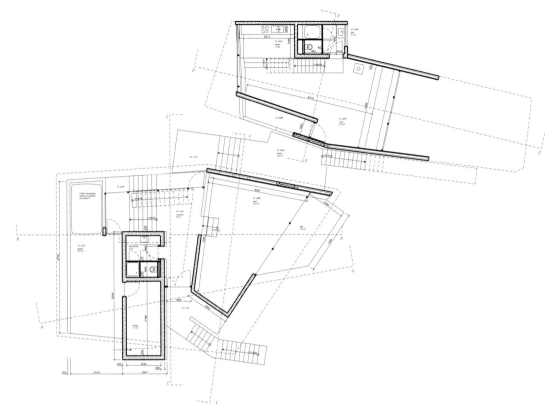

Uralla Court
Adelaide, Australia
2003

"Reading" the clients and the land resulted in an internally defined "spatial sculpture," which outlines a way of living and working together whereby choice and personal freedom are given top priority. The occupants can decide among different atmospheres, paths, and spatial situations that determine the degree of interaction or individual concentration on work. There are some areas where the space flows and moves and other areas that are stable, interweaving various purposes and creating different situations of awareness. Distance and openness interact with narrow ravine-like gaps, extroverted zones with sheltered niches and closed units. The whole house is a dance around "open shelter." The existing landscape remains present throughout the entire project; the terrain is "echoed" in the different levels flowing through the house's interior.

Together, workshop and residence build an exterior space lending an unexpectedly urban quality to the area between the two buildings and dividing the block into private and public areas. The structures form a pair whose deliberate independence, in a topographical and cultural context, is the result of intense consideration of the program and the qualities of the location.

Project Uralla Court, 2003
Site Area 1511 m²
Gross Floor Area 320 m²
Volume 1498 m³
Client Auburn & Bette, Adelaide, Australia
Structural engineering Prof. K. Wagner, Vienna, Austria

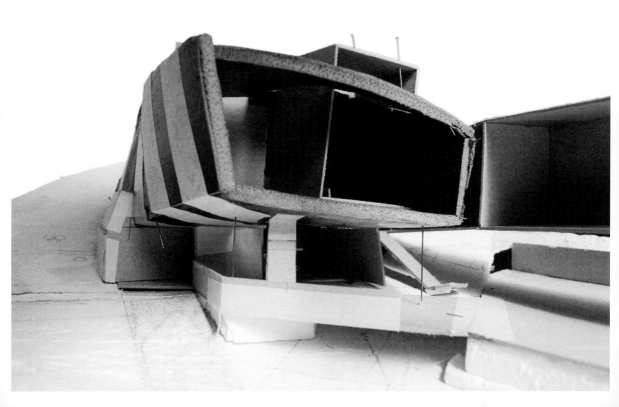

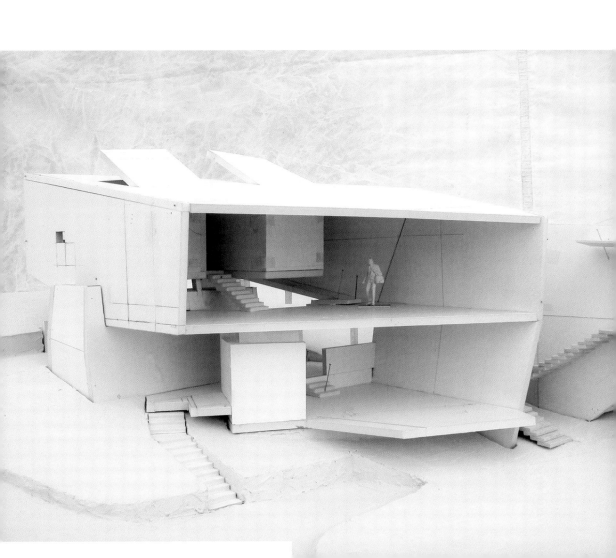

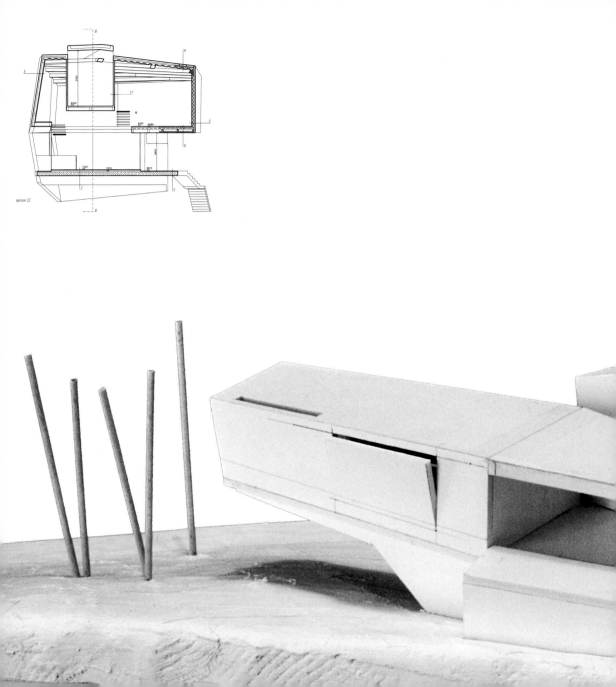

section CC

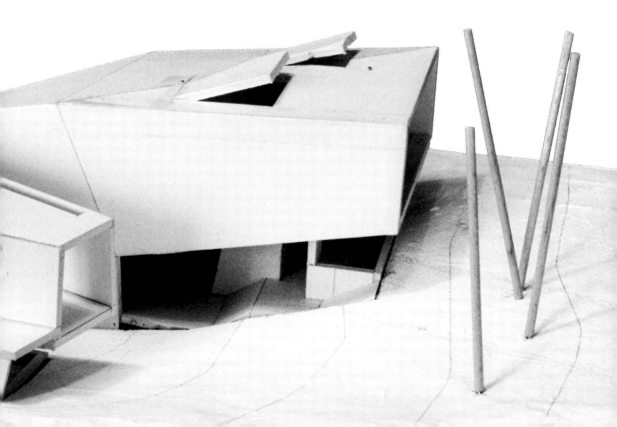

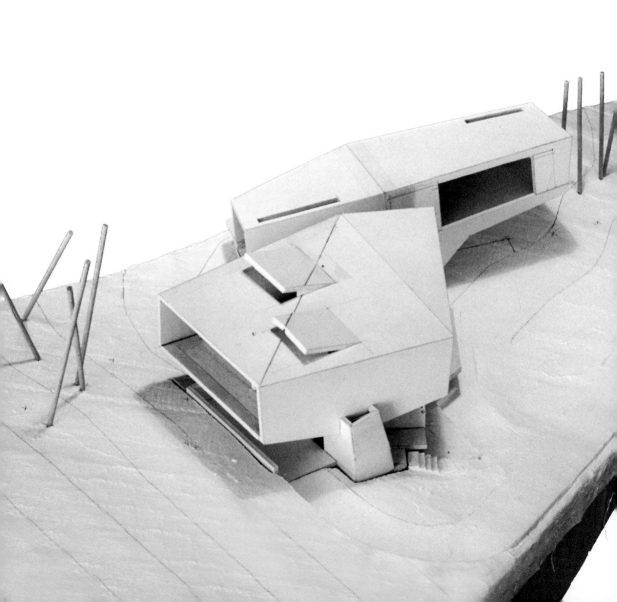

Uralla Court II
Adelaide, Australia
2005–

The redesign of Uralla Court with
new parameters: The reduction of the
volume by two-thirds. Previously
enclosed areas on the ground floor are
now used as sheltered outdoor spaces.
The steel frame structure sits on an
exposed reinforced concrete pedestal.
Roof and façades are ventilated.
The façades are clad with aluminum
sheet metal. A corrugated galvanized
steel roof collects rainwater, which
is stored in an onsite tank. A solar
module for hot water is fitted onto
one of the skylights.

Project Uralla Court II, 2005
Opening 2007
Site area 1511 m²
Gross floor area 120 m²
Volume 512 m³
Client Auburn & Bette, Adelaide, Australia
Structural engineering D.I.O.Englhardt,
Vienna, Austria; GHD, Adelaide, Australia

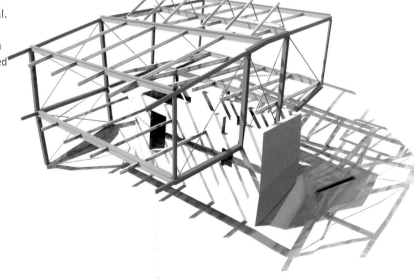

The dragon in the sea
Okinotorishima, Japan
2000

The eroding island Okinotorishima is situated in Japan's southernmost territory in the South Pacific Ocean. At high-tide, two rocks, three and five meters wide, are all that remain of the island. Without these rocks Japanese territory would end with Iwo-Jima and the country would lose 400 000 square kilometers of its territorial waters and, thus, the rights to the fish and minerals located there. Each typhoon diminishes the rocks' protruding surface area, which is why the Japanese government is willing to spend 250 million U.S. dollars to protect the island. Crucial is that no part of the supporting structure touches the island, as that would render it an artificial island with no rights to an exclusive economic zone.

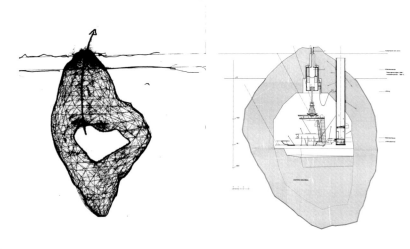

The dragon in the sea is the choreography of an annual ritual. Orientated on its volcanic origin, rock material from its interior is smelted onto its peak to replace the loss from erosion. This will save the island from legal issues of territoriality for approximately 600 years.

Project The dragon in the sea, 2000
Island area 12 m²
Gross floor area 50–150 m²
Volume 3200 m³
Client Government of Japan
Structural engineering Klaus Bollinger,
Bollinger + Grohmann, Frankfurt, Germany

The flat as answering machine
Vienna, Austria
1997

Everybody collects something consciously or unconsciously. It's an impulse, a desire to own something, to keep it and never give it away. Collecting is an attempt to deal with the fact that time passes and is lost forever. Collecting is meant to secure identity within the permanent passage of time through material proof.

The flat as answering machine stores time and atmosphere. While the inhabitant is out, the flat collects what happens; noise, light, smells, visitors, weather, etc. It bridges the gap between the videotaped family event and the time not experienced at home.

Project The flat as answering machine, 1997
Site area 400 m²
Gross floor area 300 m²
Volume 2500 m³
Client Kika, Vienna, Austria
Structural engineering D.I. Franz Sam, Vienna, Austria

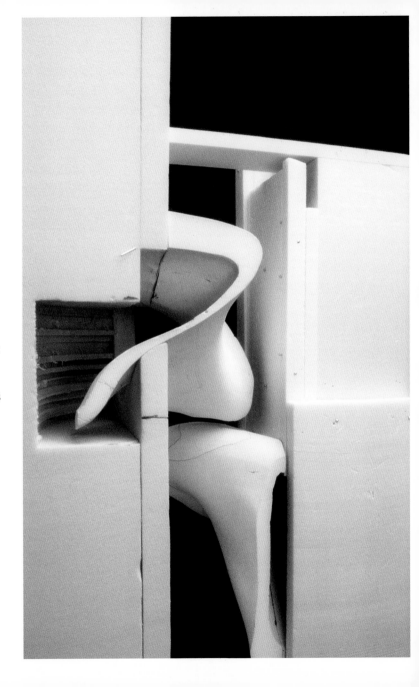

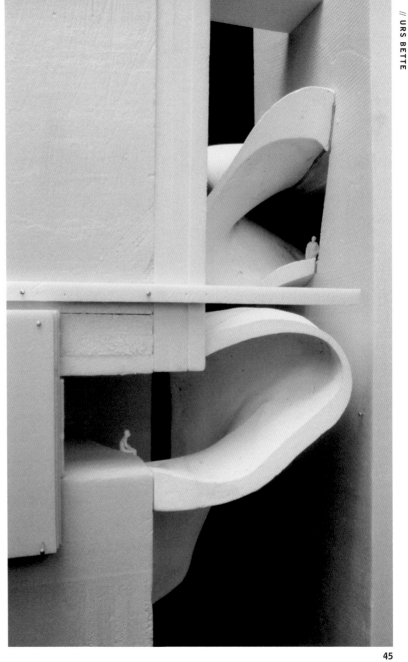

DELUGAN MEISSL

The architectural office DELUGAN MEISSL ASSOCIATED ARCHITECTS was founded in Vienna by Elke Delugan-Meissl and Roman Delugan in 1993 as Delugan_Meissl. In 2004, three new partners—Dietmar Feistel, Martin Josst, and Christopher Schweiger—joined the team, which since then appears as DELUGAN MEISSL ASSOCIATED ARCHITECTS.
www.deluganmeissl.at

Beam, residential development Donaucity, Vienna, Austria, 1998
Residential development Oberlaa, Vienna, Austria, 1998
House J, Absam, Tyrol, Austria, 2000
Mischek-Tower, Donaucity, Vienna, Austria, 2000
Town house Wimbergergasse, office and residential building, Vienna, Austria, 2001
Residential development Paltramplatz, Vienna, Austria, 2002
Global Headquarters Sandoz, Novartis Company, Vienna, Austria, 2003
House Ray 1, Vienna, Austria, 2003
Kallco City Lofts Wienerberg, Vienna, Austria, 2004
Apartment Unit 8-II "Deep Surface," Phoenix City, Beijing, China, 2004
Residential high-rise Wienerberg, Vienna, Austria, 2005
House RT, Austria, 2005
Vienna airport, competition—second prize, Vienna, Austria, 1999
OMV Administrative building, competition—second prize, Vienna, Austria, 2001
Panorama Lift Mönchsberg, competition—first prize, Salzburg, Austria, 2003
Adi Dassler Brand Center, competition—first prize group, Herzogenaurach, Germany, 2004
Office building Praterstern, competition—second prize, Vienna, Austria, 2004
Porsche Museum, competition—first prize, Stuttgart, Germany, 2005
FH-Campus Vienna, competition—first prize, Vienna, Austria, 2005
Filmmuseum Amsterdam, competition—first prize, Amsterdam, Netherlands, 2005

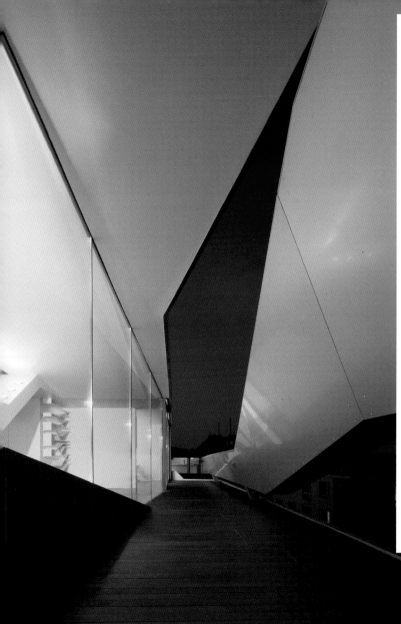

House Ray 1
Vienna, Austria
2003

Ray 1, in Vienna's skyscape, situated on the flat roof of an office building from the 1960s, is first generated from this immediate context and the spatial quality of this site.

The new building develops from the connection of the two adjacent buildings, in that it continues the gable line and produces the missing link, as it were. The demarcation line between heaven and earth is, however, not understood here as the final separation of roof and surrounding context, but instead as a permeable border that becomes a living environment.

Through recesses and layering, transparent areas and protected terrace landscapes form on both sides of the building, which make it possible to experience the exposed location and the walk-on roof.

The outer skin, layered with Alucobond, formulates sculptural, varied values, multiple zones and niches, with the aim of transforming the building's frame into furniture. The interior is designed as a generous loft, with the various functional realms defined through folds and height differentiations.

Client Delugan Meissl
Start of planning 2000
Completion 2003
Floor area 230 m²
Property area 340 m²

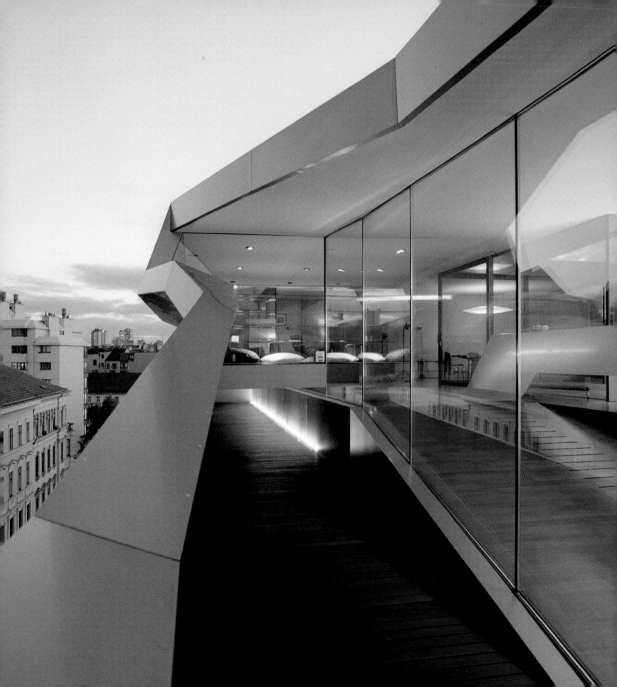

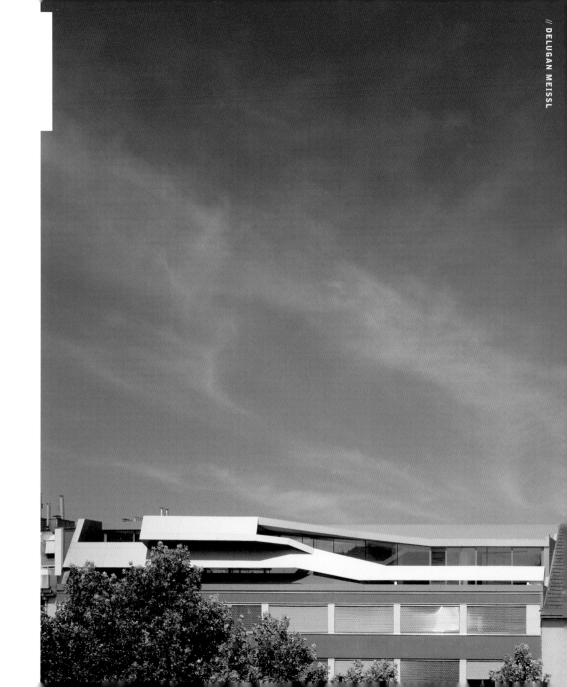

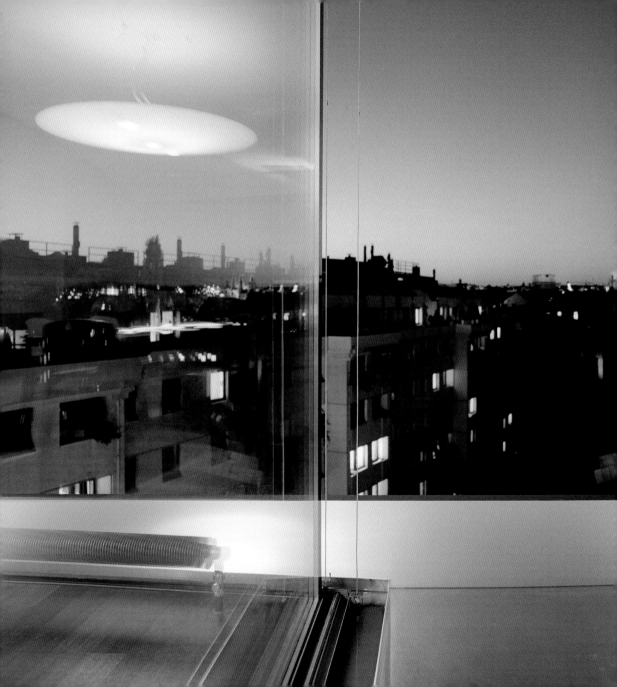

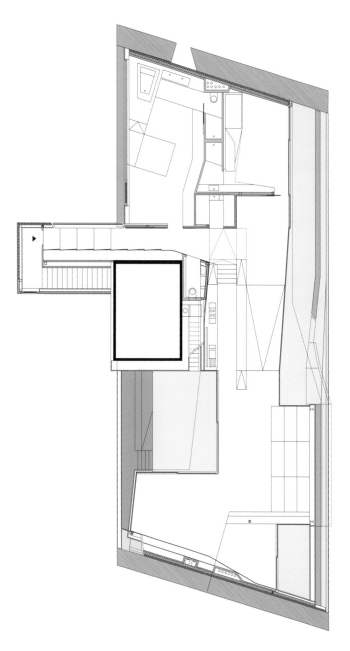

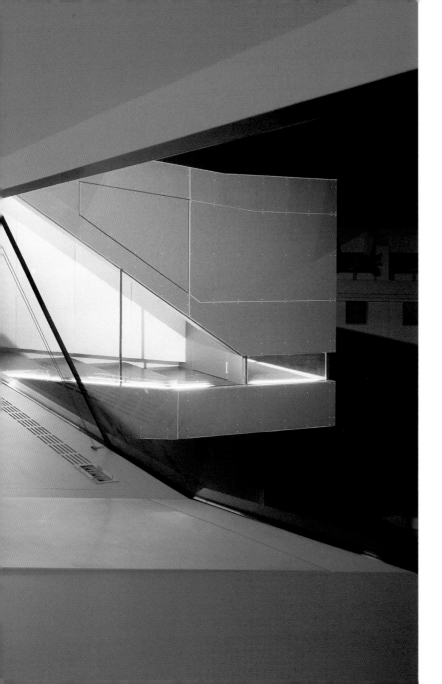

Competition first prize, 2005
Completion 2009
Gross floor area 8000 m²
Floor area 5500 m², four cinemas, exhibition,
information center
Awarded by ING Real Estate

Filmmuseum Amsterdam
Amsterdam, Netherlands
2005

The theme of "film" as a metaphorical
experiencing of space.
In the concept for the Filmmuseum,
the idea is a harmonious combination
of the arts of architecture and film,
a conclusive connection of spatial
sculpture and spatial depiction. Light
is an essential component of the
architectural concept. Just as light
can be considered the "chief archi-
tect" of this building, when it casts
a fragmented picture of alternating
day and night moods with the seasons'
different shadows on the reflecting
glass skin, it is also the "chief
director" of that same film.

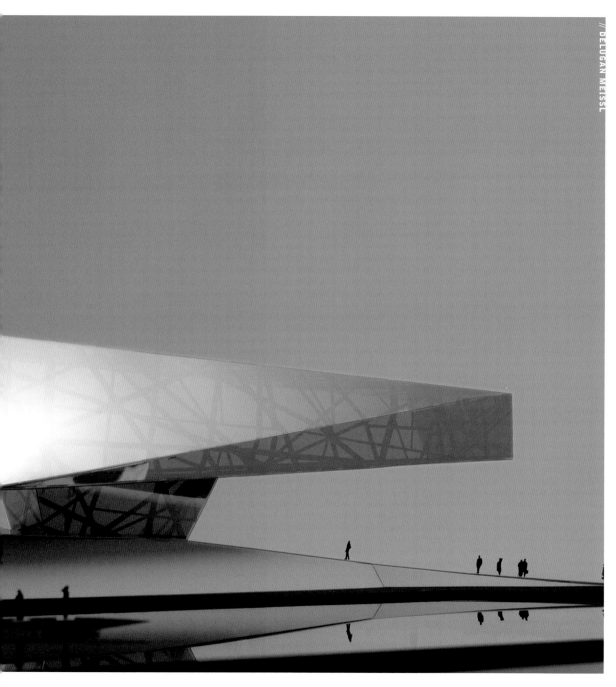

Porsche Museum
Stuttgart, Germany
2005

The new Porsche Museum creates
a site that lends architectural
expression to the self-confident
attitude of the company and at the
same time accommodates Porsche's
dynamics.

The concept of the museum is
a detached monolithic body, which
seems to float above the folded
topography of the ground floor level.
The extensive showroom forgoes any
hierarchical principle of organization
and demonstration of a single, linear,
preset method of approach: cross-
references become apparent and can
be understood in spatial and content-
based connections.

Competition first prize, 2005
Completion 2007
Client Porsche AG, Stuttgart, Germany
Exhibition 5000 m²
Catering 500 m²
Museum shop 200 m²
Classic workshop 1000 m²
Conference area 700 m²

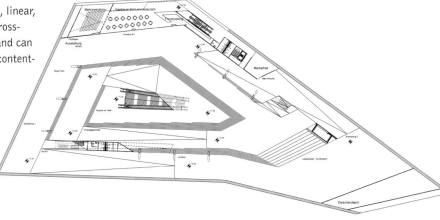

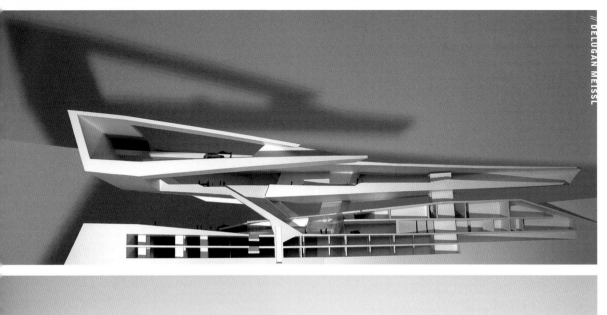

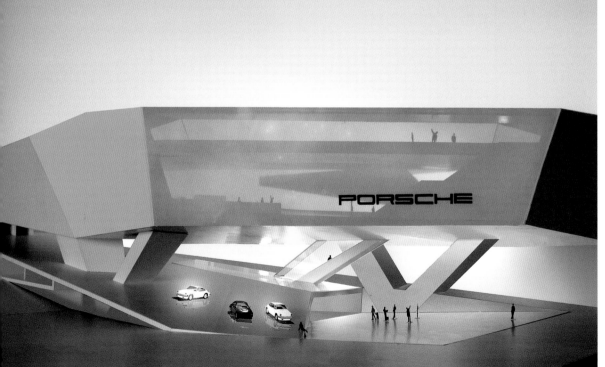

Panorama Lift Mönchsberg
Salzburg, Austria
2003

The opening of the Mönchsberg
Museum through the panorama lift
goes far beyond a purely functional
demand—instead, here, the specta-
cular trip up becomes an event.
Not following a linear connection, it
instead takes place as the movement
of the cabin following along the
mountain.
Like a long exposure, it becomes
visible during the time of its entire
course and becomes manifest as an
architectural sign in its embrace
with Mönchsberg.

Competition first prize, 2003
Height 60 m
Cabin capacity 20–25 persons
Floor area foyer/bottom station 54 m²
Awarded by Salzburg AG

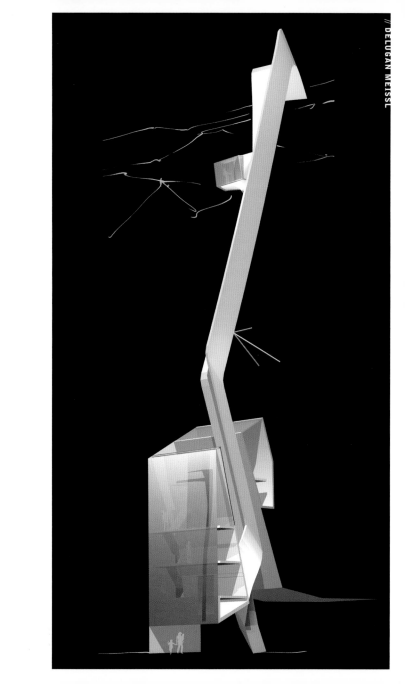

the next ENTERprise architects

The next ENTERprise was founded in 2000 by Marie-Therese Harnoncourt and Ernst J. Fuchs. Marie-Therese Harnoncourt graduated from the University of Applied Arts Vienna, Studio Wolf D. Prix in 1993, and, after a working stint in New York joined THE POOR BOYs ENTERPRISE. She has held teaching engagements at the Vienna University of Technology, the University of Applied Arts Vienna, and the University of Art and Design Linz. Ernst J. Fuchs graduated from the University of Applied Arts Vienna, Studio Wolf D. Prix in 1994 and co-founded THE POOR BOYs ENTERPRISE in the same year. He has taught at the Innsbruck and Vienna Universities of Technology and the University of Art and Design Linz. Work by the studio has been widely exhibited and published (Venice Biennale, Italy, 2004; 5th Biennale for Architecture, São Paulo, Brazil, 2003; Archilab 5, Orléans, France, 2003; "Latent Utopias," Graz, Austria 2002). www.thenextenterprise.at

Open-Air Pavilion, competition—first prize, Grafenegg, Austria, 2005–
Gänserndorf Summer Festival Area, competition, Gänserndorf, Austria, 2004
Wilhelmskaserne, urban planning competition, Vienna, Austria, 2004
Denzel Cluster, urban planning competition, Vienna, Austria, 2004
Auer-Welsbach-Straße Apartments, Building 2 Vienna, Austria, 2003–
Fidesser House, Retz, Austria, 2003–
Nam June Paik Museum, competition, Kiheung, South Korea, 2003
Harterplateau Leonding, urban planning, competition, Leonding, Austria, 2003
How to Start a City, urban planning study, Vienna, Austria, 2003
Schindler's Paradise, competition, Los Angeles, USA, 2003
Lakeside bath, competition—first prize, Caldaro/Kaltern, Italy, 2002–
Olien spaces, installation, "Latent Utopias," Steirischer Herbst, Graz, Austria, 2002
Lola Loft, Vienna, Austria, 2002
Outdoor staircase Graz, Graz, Austria, 2002
Audiolounge, installation, Secession, Vienna, Austria, 2002
Underground swimming pool (with Florian Haydn), Vienna, Austria, 2001
Observation deck, competition—first prize, MuseumsQuartier, Vienna, Austria, 2001
Blindgänger, Hof am Leithaberge, Austria, 2000
Zirl House (Ernst J. Fuchs), Zirl, Austria, 1997
Rooftop remodeling Graz (as THE POOR BOYs ENTERPRISE), Graz, Austria, 1998

Project 2003
Opening Summer 2006
Client Comune di Caldaro—Marktgemeinde Kaltern
Site area 11900 m²
Floor area 490 m² water surface; 1500 m² deck area
Collaboration Paul Vabitsch, Sigrid Weiss,
Christophe Pham, Daniel Harrer
Structural engineering concept Bollinger + Grohmann, Frankfurt,
Germany
Structural planning Ingenieurteam GmbH Bergmeister,
Vahrn/Varna, Italy
Landscaping Land in Sicht, Vienna, Austria

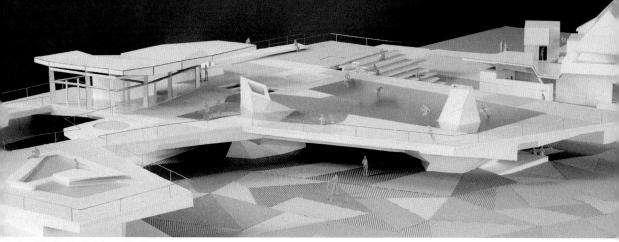

Lakeside bath Caldaro/Kaltern
Caldaro/Kaltern, Italy
2002–

Copy, Paste, and Shift
Twenty-first century leisure worlds are
readymade worlds. Whether shopping
center or water world, as a rule, they
generally arise from a synthesis of
optimized functional diagrams and
narrative surface designs. In this
project, next ENTERprise departs
from the path of the prefabricated
spectacle of water slides and wave
machines.

Part of the lake is transplanted to the
shore in a copy-and-paste operation.
Not only has the surface recurred in
the rippled texture of the concrete, but
also the spatial depths of the lake with
its underwater topographies, forming
the artificial body of water. It is pos-
sible to take the perspective of a diver
or a swimmer, a fish or a seagull
plunging into the waves, a surfer or
someone strolling on the shore or even
a theatergoer—because the lake stage,
too, is transplanted as an arena-like
atrium. This expansive mimetic

gesture does not double the specific
appeal of the natural lake; instead,
the architectonic lake re-stages the
variants of the existing water world
and adds new ones. This quotation of
nature is always something artificial
and refers to the precarious status of
our individual bodily worlds, which are
irrevocably made medial and staged.
(Angelika Fitz, April 2004)

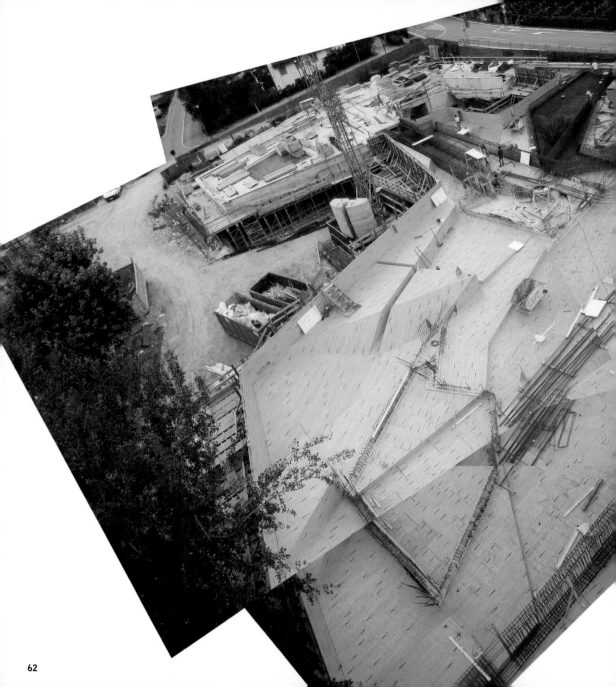

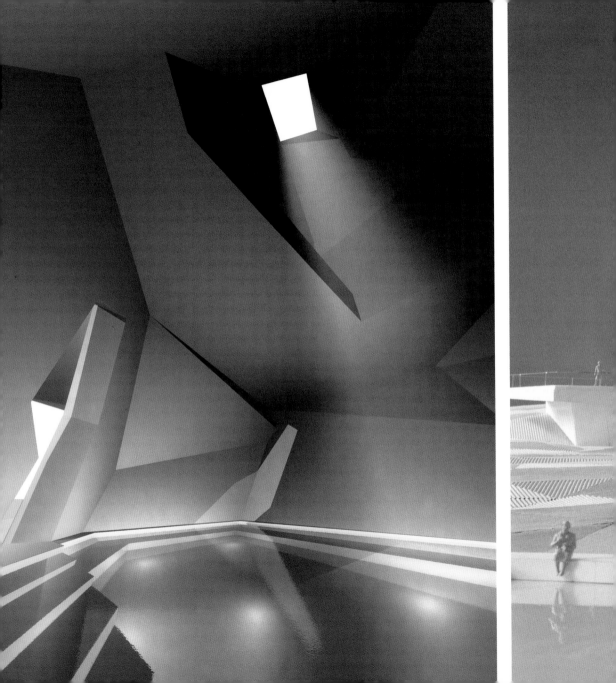

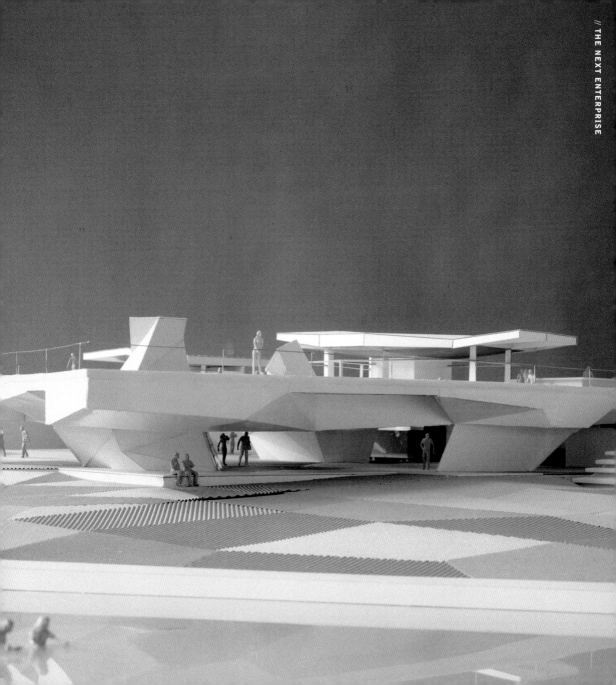

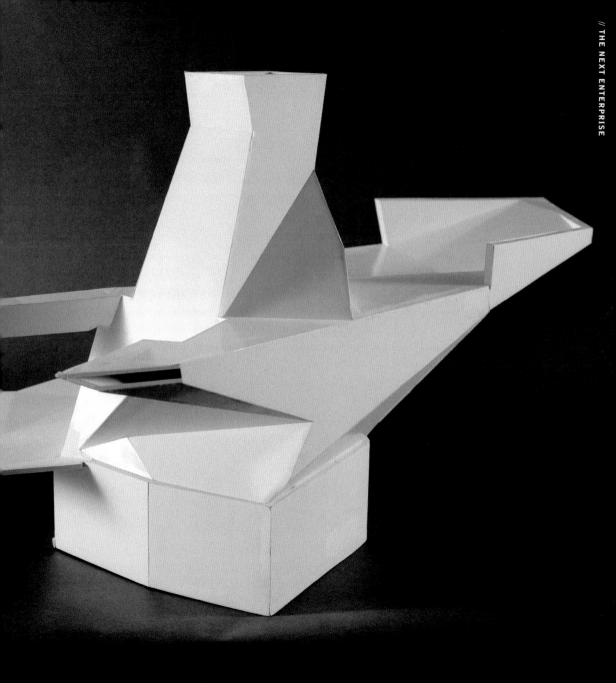

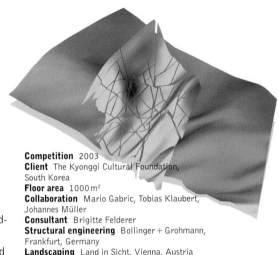

Nam June Paik Museum
Kiheung, South Korea
2003

The basic premise for the design is: site = park and park = site. The building is conceived as a continuation of the park's open spaces, pavilions, and connecting paths—as an artificial island linked to the park at different levels.

A compression process reduced the site to the stipulated area of 1000 square meters. The resulting artificial plane, containing heightened and distorted characteristics of the original terrain, was intersected with the building program, implanting it with an artificial topography to structure its spaces—a spatial field with variable densities and directional tendencies.

Competition 2003
Client The Kyonggi Cultural Foundation, South Korea
Floor area 1000 m²
Collaboration Mario Gabric, Tobias Klaubert, Johannes Müller
Consultant Brigitte Felderer
Structural engineering Bollinger + Grohmann, Frankfurt, Germany
Landscaping Land in Sicht, Vienna, Austria

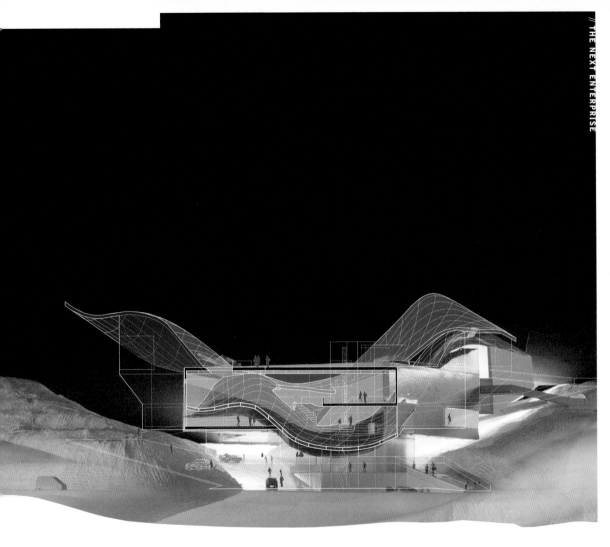

Open-Air Pavilion for Grafenegg Castle Park
Grafenegg, Austria
2005–

The basic rule of acoustics for open-air stages, "what you see is what you hear" serves as a cue to explore synergies between perspective and acoustic spaces and to redefine the relationships among the existing buildings of the park. Nestled into a characteristic terrain depression that offers a panoramic vista of the historical structures, the pavilion takes up the sightlines between the buildings and inserts itself as a new focus: serving both as a landmark— lightly disguised by reflecting the surrounding trees and clouds—and as a vantage point from which to view the ensemble.

Competition 2005
Opening 2007
Client Lower Austria
Collaboration Paul Vabitsch, Marianna Milioni, Daniel Harrer
Structural engineering Ingenieurteam GmbH Bergmeister, Vahrn/Varna, Italy
Landscaping Land in Sicht, Vienna, Austria
Acoustical engineering Müller-BBM GmbH, Munich, Germany

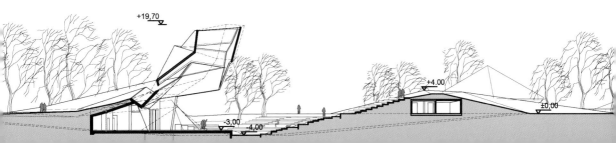

Olien Spaces/Audiolounge
Installation
Vienna, Austria
2002

Our research into what we call Olien Spaces started with the audiolounge— a sphere with computer generated "suction holes" that serve as individual sound spaces. People are drawn in by the murmur emitted from the sphere. They plunge their head into the holes to listen, with no need for earphones. The murmuring "audible aura" and the spatial configuration of the struc- ture induce the listener to succumb to an acoustically tangible spatial ambience. This capacity to "suck" visitors into a boundless, endless tun- nel, where inside and outside become blurred notions, is the starting point for a further interpretation of Olien Spaces.

Project Installation for the exhibition "Trespassing—Shaping Spatial Practices," Secession, Vienna, Austria, 2002
Client Secession, Vienna, Austria
Collaboration Mario Gabric
Curators Sandrine von Klot, Angelika Fitz

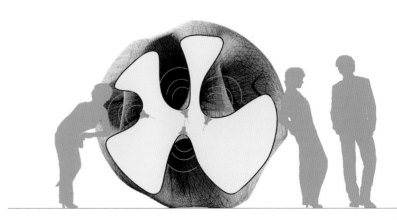

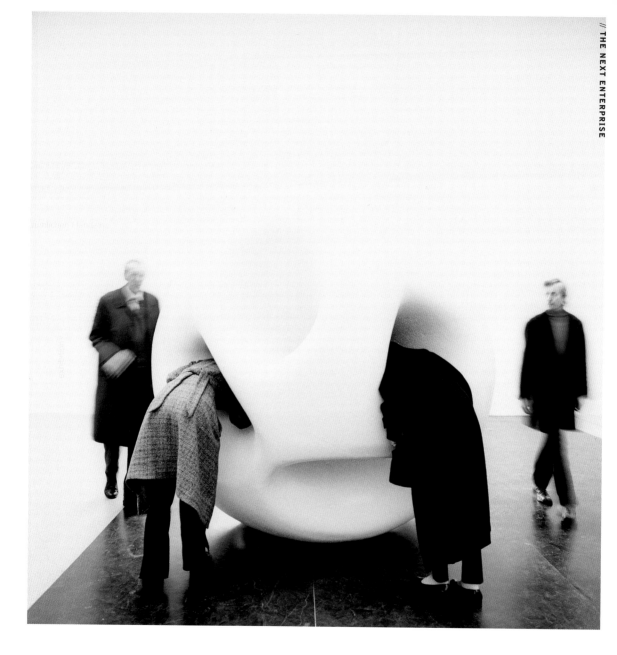

Klaus Stattmann

Klaus Stattmann, born in 1963 in Villach, Austria. Since 1993, office for architecture and research in Vienna. Most recently he curated, together with Angelika Fitz, the exhibition "Reserve of Form" at the Künstlerhaus Vienna, Austria. In 2003, he was one of the representatives of the Austrian contribution to the architectural biennial in São Paulo, Brazil. Exhibitions: "Performative Architektur," Galerie am Freihausplatz Villach, Carinthia, Austria, 2005; "Rock over Baroque," Kunsthaus Mürzzuschlag, Styria, Austria, 2004; "A Tribute to Preserving Schindler's Paradise," MAK Center, Los Angeles, USA, 2003; "Trespassing," Secession, Vienna, Austria, 2002. Numerous lectures, research projects (Theodor Körner award from the city of Vienna, Austria, 1997), and publications, including editing the exhibition catalogue for "Reserve of Form." www.splus.at

Fluc_2, bar and music club in a pedestrian underpass, Vienna, Austria, 2003–2006
Zwischenraum, performative housing for an art work, Mistelbach, Austria, 2003–2005
Leisure Housing, "A Tribute to Preserving Schindler's Paradise," MAK Center, Los Angeles, USA, 2003
Reef Vienna, study, Vienna, Austria, 1998/2003
Accidental Tower Dublin, competition for the Landmark Tower / U2 Studio Dublin, Ireland, 2003
Leisure House Lorrimer, inhabitable satellite for a house by the sea (not realized), 2002
DSVR (The sentence of the space), "Trespassing" exhibition, Secession, Vienna, Asutria, 2002
Imago Mundi, event structure, "Manifestos of Living," Künstlerhaus Vienna, Austria, 2002
Kinsky House, with Ernst J. Fuchs, Lower Austria, 2000–

Project Fluc_2, music and art club
in a pedestrian underpass, Vienna, Austria
Location Praterstern, Vienna, Austria
Client Bock Wagner OEG
Property owner City of Vienna, Austria
Floor area 412 m²
Planning period, completion 2003–2006
Collaboration Christian Bauer, Sven Klöcker
Structural engineering Christian Aste, Innsbruck, Austria

Fluc_2
Vienna
2003–2006

In a central urban planning site at Vienna's Praterstern, a pedestrian underpass and a former public restroom became the starting point for the events club Fluc_2. The legendary music and art club Fluc_1 had to make way for reconstruction work at this busy traffic junction in the course of Vienna's hosting of the European Soccer Championships.

The architecture of the new insertion and addition is committed to Fluc's performative practice, which is characterized by situational redesigning. A container ensemble is occupied by reef-like structures (see also Reef Vienna) and combined with homemade and bricolage elements. Below and along the four-lane city street is an "accidental course" of loosely linked "fluctuating rooms" with subtly differentiated sound technology requirements, playing situations, and possibilities for alteration. The three-dimensional contingency of this "untidy drawer" is not subordinate to any imperative of the whole. Fluc_2 is the materialized evidence that participation is not stimulated by pseudo-neutral containers, but instead, through aesthetic and structural complexity—as long as it is recognizable as contingent and partially temporary performances of spatial contexts.

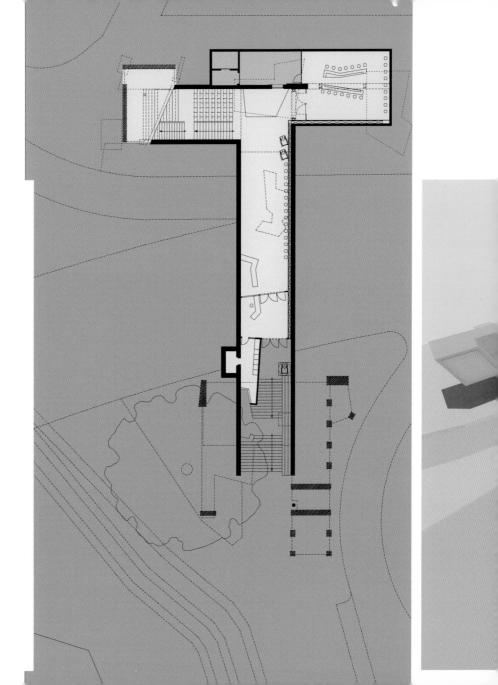

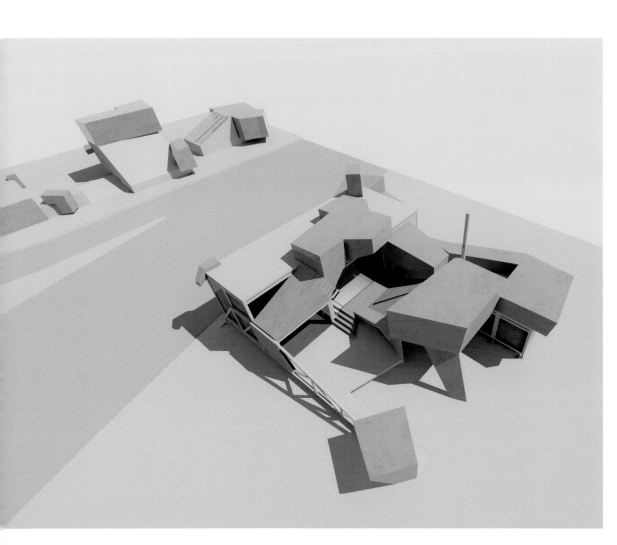

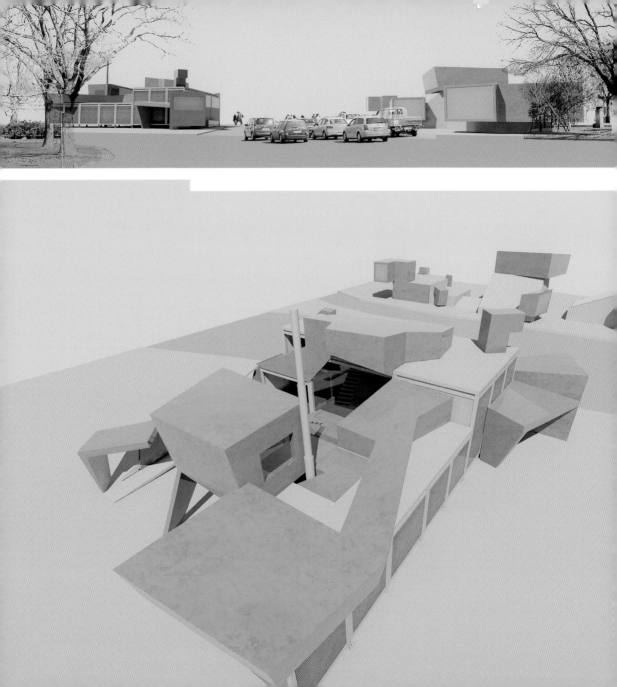

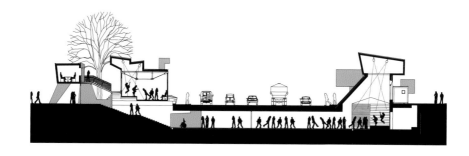

Reef Vienna
Vienna, Austria
1998/2003

Performative interspace along the
Danube canal, length: 1.3 km.
No longer landscape and not quite
architecture, Reef Vienna is similar to
the coral reef, an interspace whose
biological identity can be ascertained
as something between plant and
animal. As a performative interspace,
Reef oscillates between topographical
generator and rehearsal stage for
a steady flow of different users who
assemble constructions, add to them,
and tear them down again. In its
spatial and temporal enrichment of
the property, Reef Vienna is intended
as response to the increasing "man-
agement" of urban space, a plea
for heterogeneous interference that
cannot always be controlled or
planned.

Project Reef Vienna, performative interspace
along the Danube canal promenade, Vienna, Austria
Length 1.3 km
Floor area 20 000 m²
Planning period Study 1998, reworked study 2003
Collaboration Martin Murero

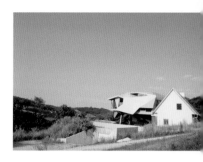

Kinsky House
Lower Austria
2000–

The site on a north-south slope of the Vienna Woods already contains a house with an orchard and is otherwise designated as meadow land. The architectural concept confronts the landscape protection and building regulations with a performative transformation of the rules. The house's dimensions remain in their existing proportions and a livable tree sphere is added onto the orchard. The new ensemble is arranged in three systems: the old house with traditional spatial organization, the tree sphere as landscape to be conquered, and the hidden living room between garden and tree sphere.

Project team Klaus Stattmann / Ernst J. Fuchs
Client Eric Kinsky
Planning period 1997–1999
Start of construction October 2000
Floor area 260 m²
Collaboration Michael Steiner, Bernd Leopold, Johannes Müller
Structural engineering Christian Aste, Innsbruck, Austria

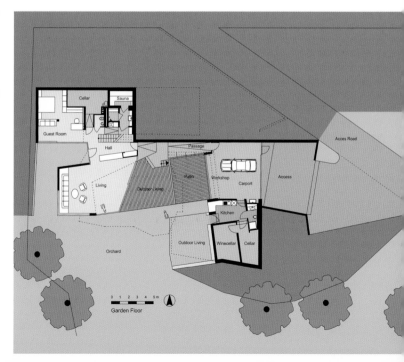

Cellar · Sauna · Guest Room · Hall · Living · Outdoor Living · Patio · Passage · Workshop · Carport · Access · Acces Road · Kitchen · Orchard · Outdoor Living · Winecellar · Cellar

0 1 2 3 4 5m
Garden Floor

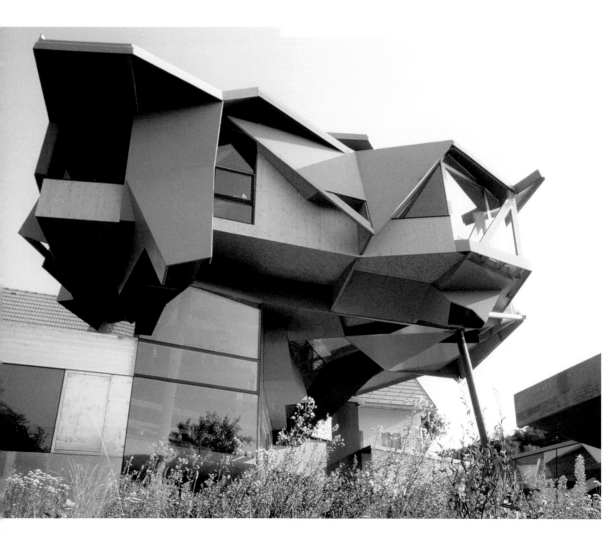

Zwischenraum
Mistelbach, Lower Austria
2005

Performative housing for the Weinviertel frieze Gemischter Satz.* The Zwischenraum serves as housing for the Weinviertel frieze by Heinz Cibulka, a 32-meter-long digital collage about the life of the region. The architectural concept refers to the commuter trains that slide like barcodes through the landscape, and have long become integral to the picture of the landscape similar to the utility poles or the silo towers. In a reversal of the passive train passenger, the beholder of Zwischenraum moves actively through the performance of landscape, from the theatrical pictorial world of the frieze through the view of the city of Mistelbach in the front window, to the horizon of Slovakia to the east of the lookout terrace.

*A vineyard planting system peculiar to Austria, whereby different types of grapes are planted together, and a blend is vinified from this "mixed batch" of grapes.

Location Mistelbach, Lower Austria
Client Stadtgemeinde Mistelbach, Austria
Floor area 57 m²
Planning period, completion 2003–2005
Collaboration Sven Klöcker
Structural engineering Christian Aste, Innsbruck, Austria

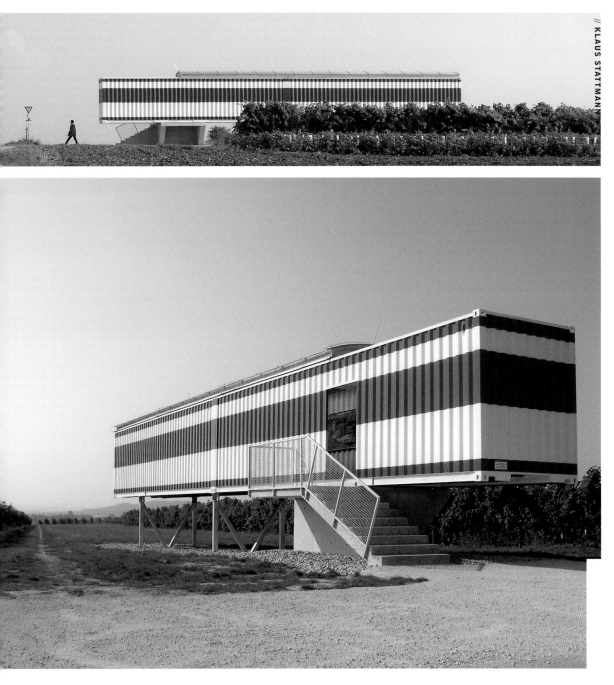

stiefel kramer, vienna/zurich

In 2003, after having worked together since 1998, Hannes Stiefel and Thomas Kramer, both Swiss, founded stiefel kramer, vienna/zurich. Hannes Stiefel worked as a draftsman and innkeeper before beginning his architecture studies at the University of Applied Arts Vienna, Austria. He received his diploma in 2000 from the Master Class of Wolf D. Prix. Thomas Kramer studied history and German studies, worked as a film historian in Vienna, and wrote and edited several books on European film history, history, and architecture. From 1998 to 2004, journalist at the Tages-Anzeiger, since 2005, chief editor culture at the weekly paper Die Weltwoche. Hannes Stiefel was a guest professor at the University of Innsbruck, Austria, from 2001 to 2004, and at the SCI-Arc Vico, Switzerland, in 2005. Since 2004 university lecturer at the University of Applied Arts Vienna. Collaborations with Daniel Lüthi and Georg Kolmayr. Numerous exhibitions, publications, and lectures. www.stiefelkramer.com

Portals and Ventilation Buildings Roppener Tunnel, "Noses," competition—second prize, Tyrol, Austria, 2005
Ski World Cup Stadium and Base Station Planai, competition, with Georg Kolmayr, Schladming, Austria, 2005
Kunsthalle Bremen, extension, competition, with Georg Kolmayr, Bremen, Germany, 2005
Viewpoint Tower, "Doppelwendel, neroisch," competition, with Georg Kolmayr, Xanten, Germany, 2004
"Dada-Haus/Cabaret Voltaire," concept study, with Juri Steiner, Zurich, Switzerland, 2003
Waterford North Quays, master plan and venue building, competition, Waterford, Ireland, 2002
Medialab University of Visual Arts Leipzig, competition, with "complizen," Leipzig, Germany, 2001
Dynamic Labyrinth, urban development, competition—prize of the jury, Zurich, Switzerland, 2001
Swiss National Museum, extension, competition, Zurich, Switzerland, 2000
Kunsthaus Graz, "Promenade médiale," competition—second prize, Graz, Austria, 2000
"The Continuous House—a Goyan horse," diploma project, South Australia, 1999–2000
Adaptation of a seminar building, "Aquaplan," competition, Hamburg, Germany, 1998
Amevor House and Hotel, "Ho Kabakaba" (1997: with Urs Bette, Andreas Haase), Ho, Ghana, 1997–99/2004–
Libro Megastore, "The big and the flat," competition—first prize, Vienna, Austria, 1996
Single family residence, Saland, Switzerland, 1996
Theater for Tragedies, "Memento mori," Los Angeles, USA, 1994–1995
Spreebogen, urban study, competition, Berlin, Germany, 1992
Urban design for Bundesplatz Bern, competition, Berne, Switzerland, 1991

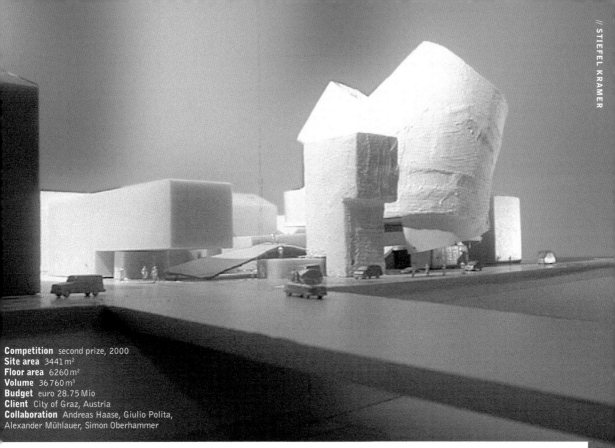

Competition second prize, 2000
Site area 3441 m²
Floor area 6260 m²
Volume 36 760 m³
Budget euro 28.75 Mio
Client City of Graz, Austria
Collaboration Andreas Haase, Giulio Polita,
Alexander Mühlauer, Simon Oberhammer

Kunsthaus Graz, "Promenade médiale—a Continuous House" Graz, Austria 2000

In Graz, when people speak of the "other" or "far" side they mean the part of the city that is west of the Mur river. The Kunsthaus is meant to stand on that "other" side, across from the historic center and the hill Schlossberg. For the city, it is necessary to design other spaces, other realities for a house of art. Art is its own reality; neither depiction nor doubling: it is not a copy. The Kunsthaus represents surveillance machines, art digestion, production sites, stage, knowledge transfer, transit space, and is, at the same time, a contemplative place. We are developing for it a "spatial program of other views" that is not defined by the square meters of the floor area.

With the spatial composition of our Kunsthaus, which is characterized by the exchange between city space and interior space, we attempt to establish a dialogic exchange between the city's reality and art's own reality—programmatically, functionally, and in terms of urban development. As a moving observer, the museum guest is accustomed to always also perceiving things in a transformed state caused by a change of perspectives. The entire city thereby becomes an art space, a reference value for the Kunsthaus—and the hill Schlossberg becomes part of the spatial program.

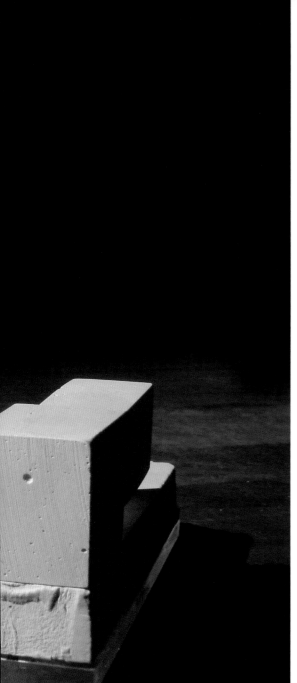
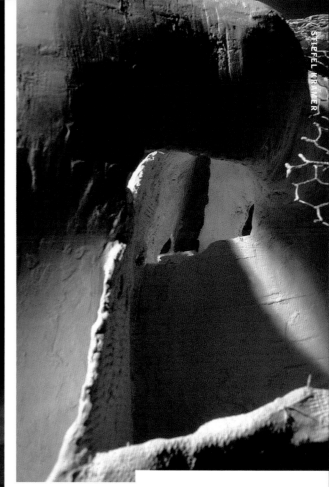

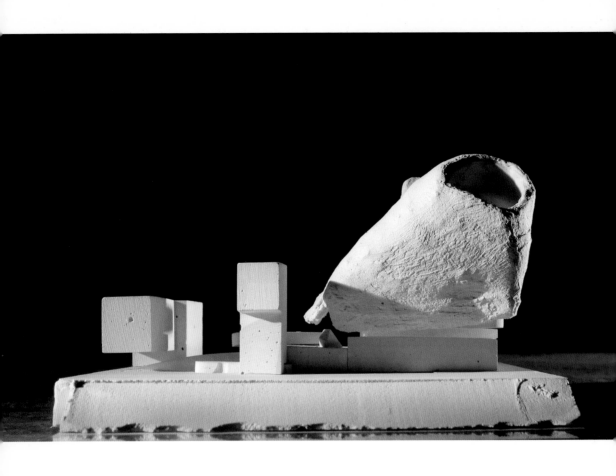

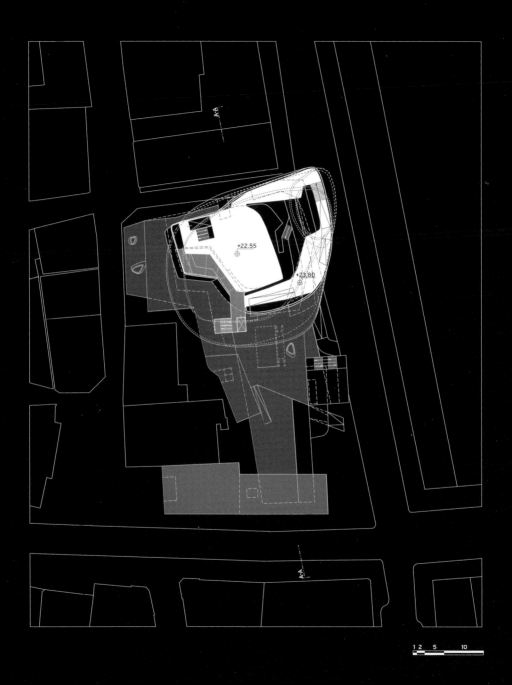

+22.55

+23.80

1 2 5 10

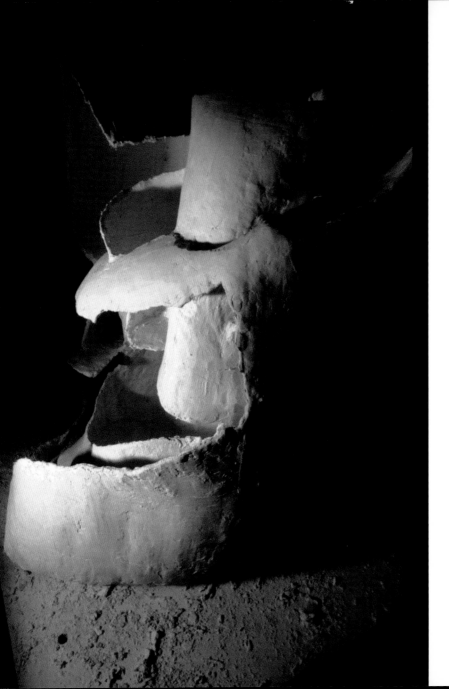

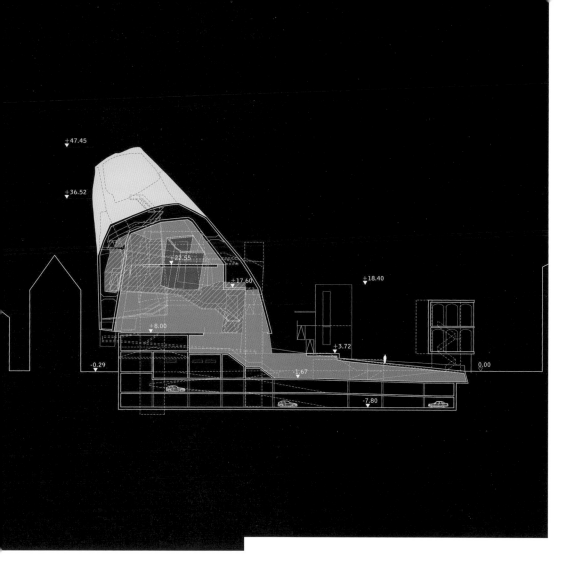

+47.45

+36.52

+22.55

+17.60

+18.40

+8.00

+3.72

0.00

-0.29

-1.67

-7.80

Diploma project Hannes Stiefel, University of
Applied Arts Vienna, Austria, 2000
Prize of Austria's Federal Minister of
Education, Science and Culture
Acknowledgements Thanks to the members of
Wolf D. Prix's Master Class, 1999–2000

"The Continuous House—a Goyan horse," Diploma project
South Australia
1999/2000

A study on the variability of the
physically manifest space based on
the example of a publicly accessible
building for a picture-fanatic and
switch-thinker. Through the heuristic
interactions between observer, people
observed, and things observed, the
spaces lose their static appearance
and continually rebuild themselves.
A speculative attempt to introduce in
architecture's reception, the relevance
of discoveries in quantum physics
stating that a phenomenon changes
purely through observation.

the utopian moment/can also lie/in
the form/in the images/behind the
images/associating/goyan blackness/
in the depth of the space/paths for the
observed/observer/creating/new
realities/continuous houses

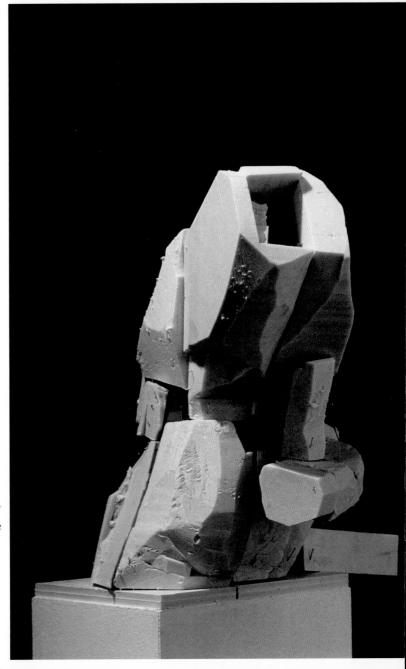

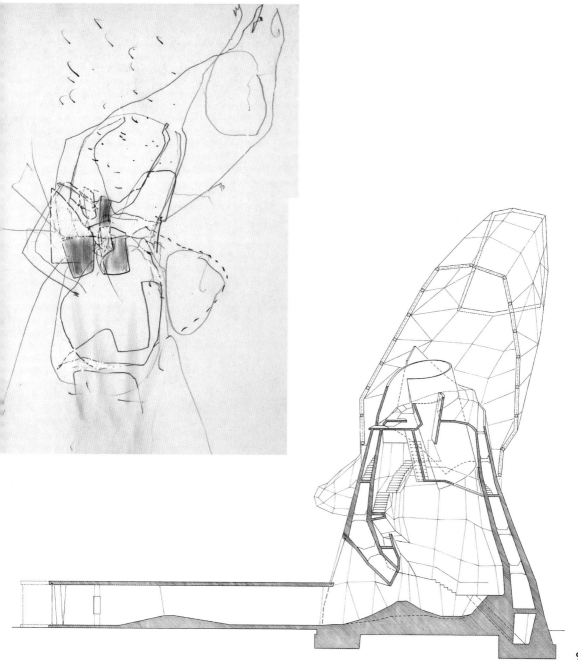

Memento mori

THEATER FOR TRAGEDIES

OR

VIENNESE CULTURE IN LOS ANGELES

(LOS ANGELES, USA)

1994/95

PLAY IN FIVE ACTS

WITH INTRODUCTION AND EPILOGUE

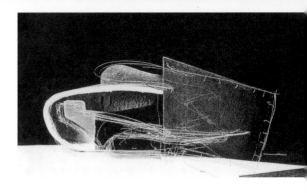

INTRODUCTION: *The Theme*

SCENE ONE (VIENNA, AUSTRIA)

About the demise of the Austro-Hungarian Empire.

SCENE TWO (VIENNA, AUSTRIA)

About Mr. Freud and the archeology of the unconscious.

SCENE THREE (VIENNA, AUSTRIA)

About the presence of morbidity in literature, art, and everyday Viennese life.

ACT ONE: *The Program*

SCENE ONE

The theater (both play and building) to stage a specific Viennese mood and atmosphere.

SCENE TWO

The theater itself as tragedy.

SCENE THREE

The precariousness of the system.

ACT TWO: *The Site, The Geology*

SCENE ONE (LOS ANGELES, CALIFORNIA)

The uncontrollable and the possible catastrophe as requisite.

SCENE TWO (WILSHIRE BLVD. HANCOCK PARK)

Natural tar pits. A hole like a pond along the boulevard, filled with tar.

SCENE THREE

The deceptive mainland: The building alternately stands, swims, sinks, and dives into the unstable surroundings of the tar pit.

ACT THREE: *The Material*

SCENE ONE

The black, sticky, stinky tar mass.

SCENE TWO

The whole complex as a closed system under pressure. A neoprene tube leads as an opening from the sluice into the foyer.

SCENE THREE

Raw, heavy concrete volume (auditorium) stands seemingly secure on the "shore," away from the sharp-edged, steel-clad support structure (stage) tipping into the "pond."

SCENE FOUR

Neoprene as connection between concrete and steel. On the top of the building a pneumatic cover forms the bar, on the side opposite the entrance it forms a café. Bar and café, with their color and soft structure, form the opposite pole to the heavy, hard main building elements. Enter: light, the pressure remains.

SCENE FIVE

The public path leads through the foyer and orchestra pit across the side stage up to the bar.

ACT FOUR: *The Time*

SCENE ONE

The movements of the stage area will be transported onto the stage by a mechanical transfer. The space will alter over a long span of time.

SCENE TWO

The stage area dives into the "pond."

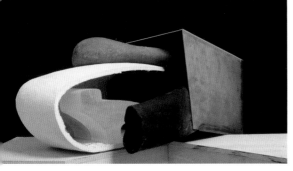
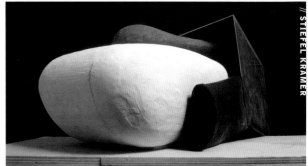

STIEFEL KRAMER

SCENE THREE
The auditorium slowly punches through the "shore."
SCENE FOUR
Calculated theoretically, it will take seven to ten years for the building to submerge completely. The theater is usable and functional at all times.

ACT FIVE: *The Earthquake*
SCENE ONE
Expected earthquakes can change the calculated chronology of events and prognosticated course of movements considerably.
SCENE TWO
An earthquake will be immediately transferred to the stage through the stage's mechanical construction, and will thereby become part of the staging.
SCENE THREE
"The Big One" will stage the last play.

EPILOGUE: *On Viennese Hedonism*
Even when the theater has sunk, the bar, of course, will float on the top.

Project 1994–1995, Austrian Federal Award for Experimental Architecture
Collaboration Jason Luk

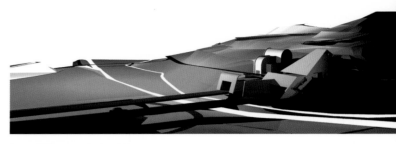

"Noses," Portals and ventilation buildings for the second tube of the Roppener Tunnel
Tyrol, Austria
2005

The project "Noses" continues our confrontation with the transformation of urban and rural spaces. Here, we transformed transitory sites (the area surrounding highway tunnels) into new spaces. The perception and use of these spaces changes fundamentally according to the observer's distance, speed, type of locomotion, and angle of vision. The "Noses" mantle the portals and ventilation buildings of a highway tunnel in an alpine environment. Rather than merely designing a skin for the ventilation buildings, we established "Noses" as an accessible spatial sequence between the different layers of a multilayered skin. These contemplative spaces communicate strangely with the inhospitable, highly frequented transitory site of the highway.

Competition second prize, 2005
Client ASFINAG Autobahnen- und Schnellstraßen-Finanzierungs-Aktiengesellschaft
Floor area 335 m²
Building height 20.01 m/33.05 m
Budget euro 1.2 Mio
Collaboration Simon Oberhammer, Markus Ortner, Ursula Ender
Structural engineering Bollinger + Grohmann, Frankfurt, Germany
Cost calculation Hans Lechner ZT GmbH, Vienna, Austria

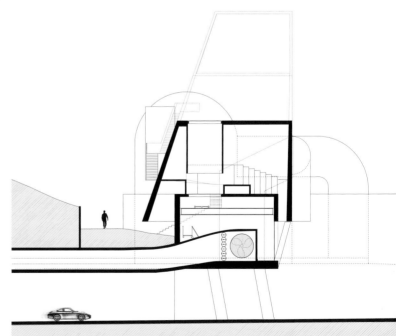

Wolfgang Tschapeller

Wolfgang Tschapeller, born in Dölsach, East Tyrol, Austria. Furniture maker's apprenticeship and journeyman's exam, studied architecture at the University of Applied Arts Vienna, Austria, and Cornell University, Ithaca, NY, USA (postgraduate studies, MA). Since 1993, civil engineer with office in Vienna, Austria. Visiting critic at Cornell University; Inha University, Seoul, South Korea; and the Haus der Architektur in Graz, Austria. Visiting critic at the University of Arts, Linz, Austria, 2003; Mc Hale Fellow at State University of New York, Buffalo, USA, 2004; Academy of Fine Arts Vienna, Austria, 2005.

THAW, project for the Theater an der Wien, competition, Vienna, Austria, 2005
Hotel in the park of Palais Schwarzenberg in Vienna, competition—first prize, Vienna, Austria, 2004
Murau, District Commissioner's Office, competition—first prize, Murau, Styria, Austria, 1996, completion 2002
Sigmund Freud Museum, Vienna, Austria, 1990–1998
BVA 123, study of urban textures, Vienna, Austria, 1998–2004

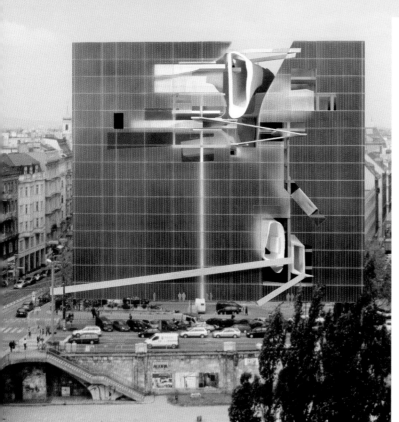

will become the principle of urban development. Volumes will be built onto skeletal constructions for public use that are accessible from the outside. The skeletons are the base, the buildings formless.

Guest rooms are independent. Guest rooms are an offer from the building stock to the public. It is as though one has put out a dish of rice here for imaginary deities.

Guest rooms are a type of tax. Guest rooms are the most luxurious rooms in a city.

BVA 3. The experimental arrangement documents movements in building-like geometries, in skeletons. Foreign bodies cause these movements in the attempt to settle in the skeletons. Both skeleton and settler are animated. They can only change their form, dimension, and mass within limits. They are in a reactive relationship with one another.

BVA 1 2 3
Vienna, Austria
1998–2004

BVA 1. The Huge Reinforced Concrete Skeleton Structures (after a few decades):

Everything is to be dismantled: the skeleton of reinforced concrete is to remain. The life span of the load-bearing skeletons exceeds that of other building elements by up to ten times. They are more or less the memory that remains of a building. The skeletal frame constitutes a three-dimensional property and could be sold zone by zone, then developed piece by piece like land. At some point, skeletal frames will no longer be erected because of their abundant availability. They belong to no one. Groups of settlers will stretch skins over skeletal frames.

BVA 2. Cavities will be eroded into existing structural masses. The public realm presses into the private. Erosion is a process of construction. Erosion

Project team Wolfgang Tschapeller, Michael Wallraff with Jörn Aram Bihain, Markus Lentsch, Michael Weingärtner, Hubert Schoba, Astrid Tschapeller, Markus Leixner, Phillip Horak, Felix Strasser
Structural analysis Bollinger + Grohmann, Frankfurt, Germany

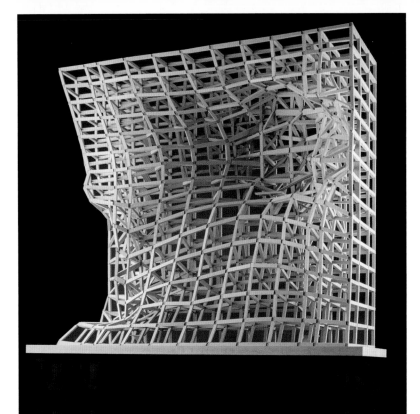

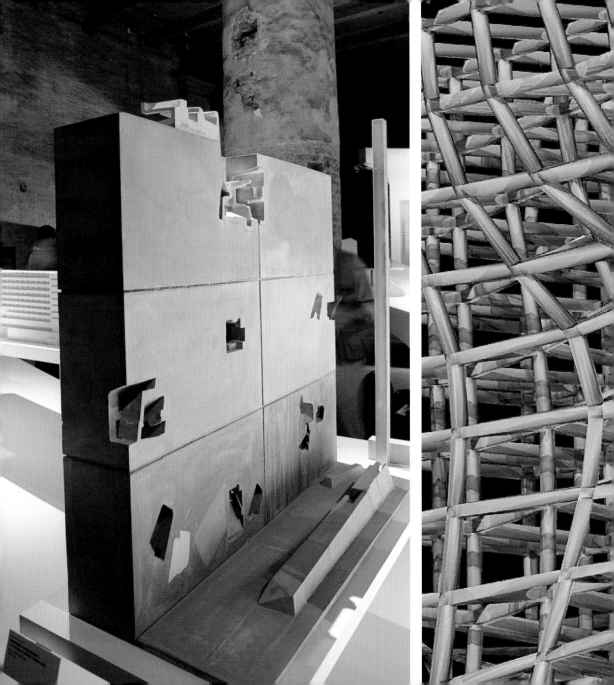

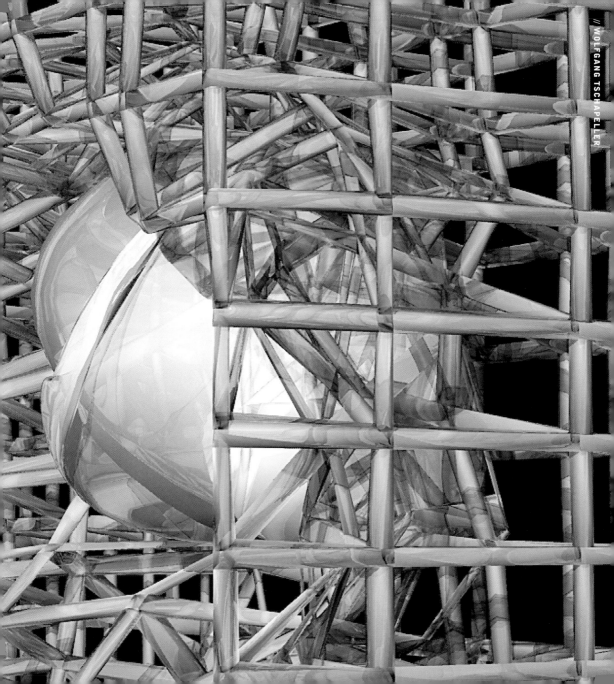

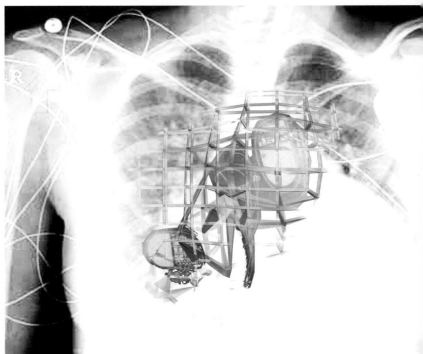

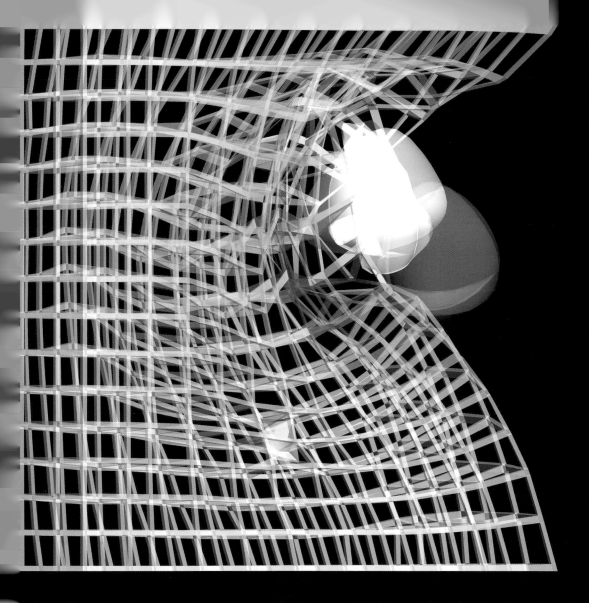

Theater an der Wien—
Entry and Foyer
Vienna, Austria
2005–2007

The Theater an der Wien has an amazing pose for a location where opera is played: It is in the second row, and therefore not visible.

The building mass is tremendous and yet, as object, the Theater an der Wien does not exist. It is swallowed by the anonymous urban mass.

That was certainly not the architect's intention. We can assume that it simply happened.

No right of way, no anteroom—instead, a foyer pushed underneath a neighboring building like a young cuckoo: a narrow space in which a portal weighs heavy.

This situation points out the erratic qualities of this era. Space allocation plans, arias, and songs gush from their historical containers, flood the urban space, are cut up by streets, cut off by commercial interests, are traced by the noise of motors. And yet songs and space allocation plans sound on.

Client Vereinigte Bühnen Wien, Vienna, Austria
Project team Wolfgang Tschapeller,
Felix Strasser, Arnold Faller

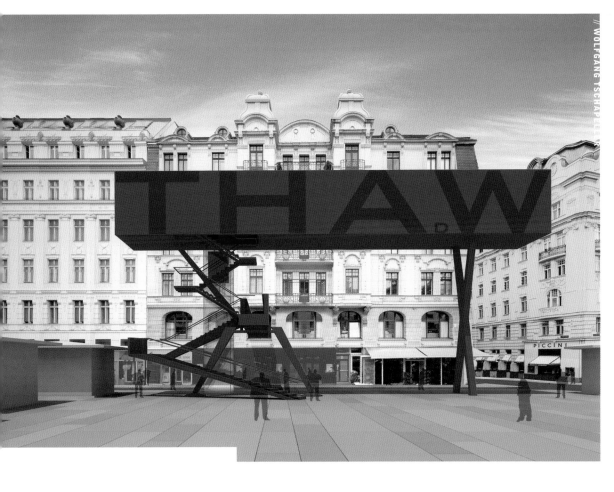

House of Photography
Bressanone, Italy
2003

The "House of Photography," for
a manufacturer of equipment for
photographic production and process-
ing in Northern Italy, will contain
a technical demonstration room, exhi-
bition space for documentation of the
history of photography, and a future
laboratory for photographic research.
It will be located there in the valley,
where the major lines of the national
infrastructure—highway, railway, and
state road—are pushed to the edge,
carving into the base of the mountain.
The "developed format"—a zone of
approximately 25 m × 25 m × 25 m—
will be constructed as an associative
conglomerate of national elements
that happen to pass by the location.
It is a construction that operates with
constructed memory, similar
to photography.

Competition project 2003
Project team Wolfgang Tschapeller,
Astrid Tschapeller, Sandra Häuplik

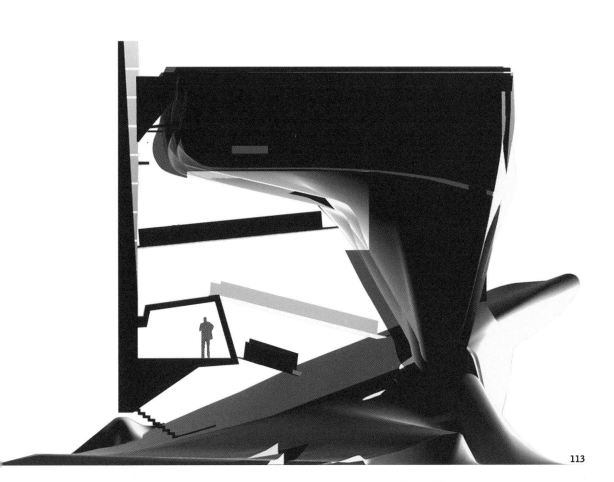

Musiktheater Graz
Graz, Austria
1998

A building for music and musical
theater should be built for the Aca-
demy of Music and Performing Arts in
Graz. A project for a building should
be decided in the framework of the
two-step competition. The essential
spatial volumes are a large auditorium
with an area of approximately
500 square meters and height of ten
meters, large rehearsal rooms for
orchestra and musical theater as well
as foyer spaces. The present project
proposal begins with the assumption
of an extreme modulation as well as
erosion of the property area. This
erosion of the surface area should be
formulated in such a way that the
functional and programmatic guide-
lines of the user are possible. I say:
"possible," because I think that the
relationship of space and that which
should take place in this space
requires a great amount of ambiva-
lence. I am thinking about a field,
how it is not really made for lying
down and sleeping, but nonetheless
is a splendid place to sleep.

Competition 1998
Project team Wolfgang Tschapeller, Martin
Scharfetter, Jennifer Whitburne
Cost calculation SGLW Architekten

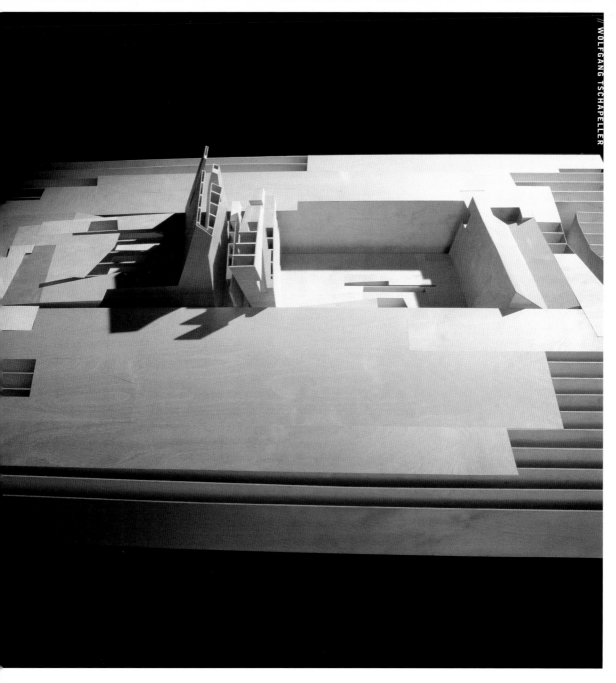

+2

Sophie Grell

Sophie Grell was born in Berlin, Germany, in 1975. She lives and works in Vienna, Austria, where she studies art history and architecture. Her work focuses on an occupation with the perception and mobility of space.

Raum oder Vorfeld
Symbol and announcement system on the site before the MuseumsQuartier Vienna
Vienna, Austria
2004–2005

The proposed structure inscribes itself into the sequence of gateway openings, which from Michaelerplatz to the front area of the MuseumsQuartier in Vienna, place urban space in a relationship with human dimensions. This opportunity to directly experience history breaks off in front of the MuseumsQuartier. The transformations in the interior of the complex are not evident on the outside: They do not appear. The roof, resolved into four elements, articulates the tension between continuity and autonomy and syncopates the rhythm of the baroque façade. A second space arises between roof and outer façade. The inner and outer edges of the roof are information trajectories, which specifically account for the various types of reception oriented them. Under the roof's first element is a pedestal-like elevated zone, which can be used in connection with the playable roof edges for various functions such as open-air cinema, exhibition area, open-air office, chill out zone, clubbing venue, or ice-skating rink.

The flexible roof condenses to a tower, which finds its dimensional correspondence in the memorial to Maria Theresia and its urban-development reference in the anti-aircraft tower. It emits its energy in a light cone. Under the tower's cone of light is an open-air stage, which could also function as an information area.

Info-stands and signposts under the roof and on the square give the information of the individual institutions within the MuseumsQuartier an image and are oriented on their respective positions. For openings and other events, the signs are directed toward the MuseumsQuartier's corresponding entryway.

Competition first prize, 2004–2005
Client MuseumsQuartier Errichtungs- und BetriebsgesmbH, Vienna, Austria
Site Area 16 355 m²
Collaboration Jesper Bork, Gregoire Dubreux, Irakli Itonischwili, Franz Sam, Angus Schönberger

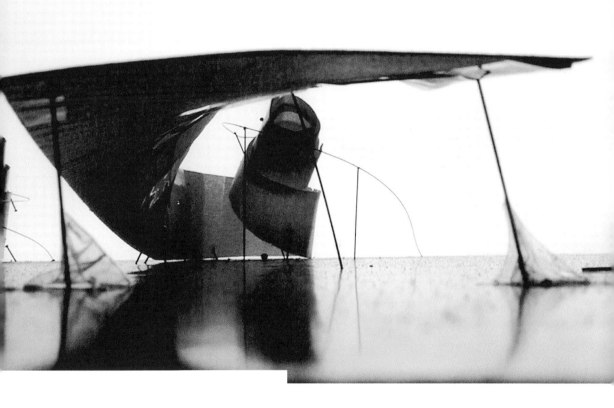

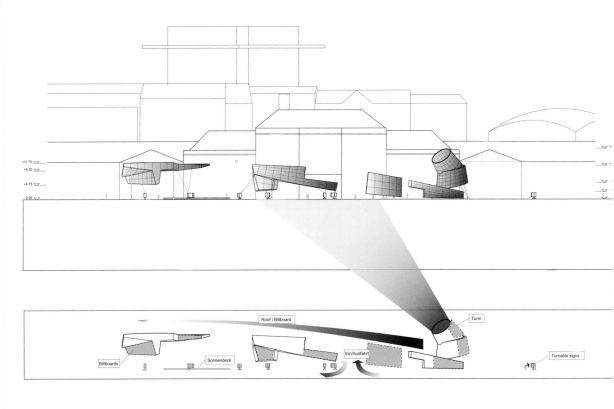

+11.75
+9.30
+4.75
0.00

Roof / Billboard

Turm

Billboards

Sonnendeck

Ein/Ausfahrt

Turnable signs

DREHBARER WEGWEISER

OPEN-AIR BÜHNE

LIEGEFLÄCHE

TURM ZUM MUSEUMSQUARTIER

BILLBOARD "STRASSENSEITIG"
PROJEKTIONSWAND

BILLBOARD
AUSFAHRT

BILLBOARD EINFAHRT

BILLBOARD
GROSSES LOGO

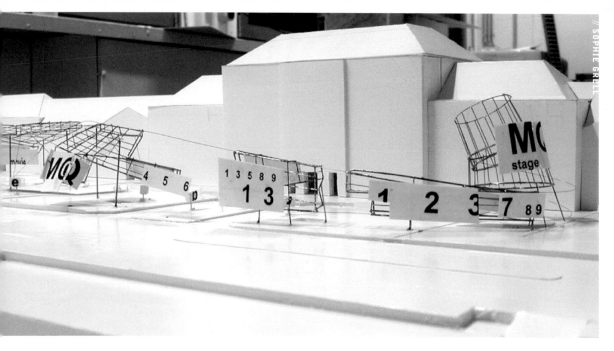

INNERE/ÄUSSERE INFORMATIONSLINIEN

RÄUMLICHE ENTWICKLUNG

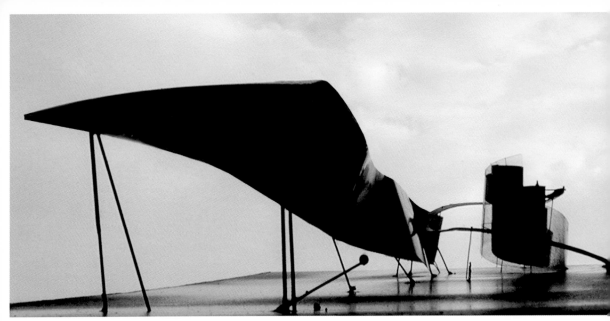

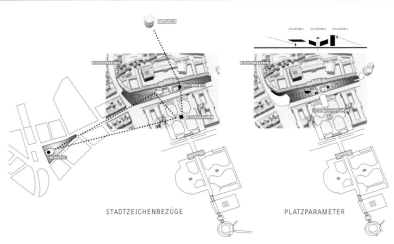

STADTZEICHENBEZÜGE

PLATZPARAMETER

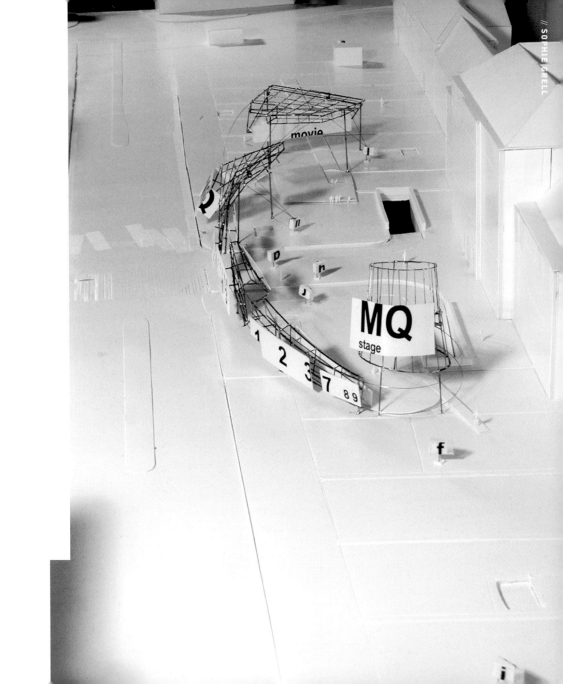

Tercer Piso Arquitectos

Tercer Piso was founded in 2002 by the participating students:
Jean Pierre Bolivar Martinez
born in Bogotá, Colombia in 1977—Site management
Dominik Brandis
born in Meran, South Tyrol, Italy in 1978—Project documentation
Alexander Matl
born in Salzburg, Austria in 1980—CAD and surveying
Giulio Polita
born in Trieste, Italy in 1970—Artistic director
Florian Schafschetzy
born in Vienna, Austria in 1979—CAD and surveying
Rüdiger Suppin
born in Vienna, Austria in 1978—Prototype testing and energy concept
Rupert Zallmann
born in Vienna, Austria in 1981—Organization

**Techo en Mexico, Studio a3,
Prof. Wolf D. Prix, Institute of
Architecture, University of Applied
Arts Vienna, Austria
2002–2004**
Techo en Mexico is the physical confrontation with the figure of the roof as an archetypical form of architecture, based on a design project that began in the summer (second) semester of 2003 in Wolf D. Prix's studio at the University of Applied Arts Vienna.

The roof, as an open spatial demarcation, sufficiently meets the minimal requirements of protection from the sun and rain. It creates a critical relationship with the landscape, from which it is largely removed. The role of the outline is to give dimensions to the space and its periphery. The line of the eaves describes a three-dimensional, distorted contour line, which, together with the symbol stretched down to the ground, generates a new image: a mise en scène of water.

A gutter visibly channels the water across the grounds to a storage tank. This tank forms the foundation for the light tower that will become a point of reference for the entire valley.

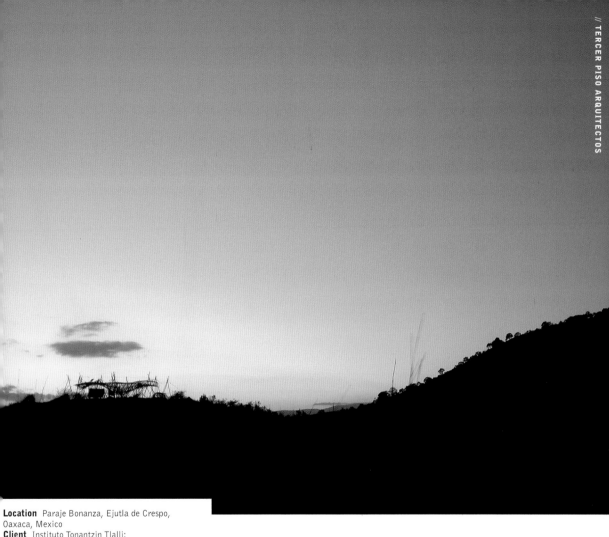

Location Paraje Bonanza, Ejutla de Crespo,
Oaxaca, Mexico
Client Instituto Tonantzin Tlalli:
César López Negrete
Building type community space
Surface area 250 m²
Project management Bärbel Müller
Design and concept assistance Bärbel Müller,
Reiner Zettl
Construction and detail assistance Franz Sam
Structural assistance Klaus Bollinger,
Bollinger + Grohmann, Frankfurt, Germany;
Franz Sam

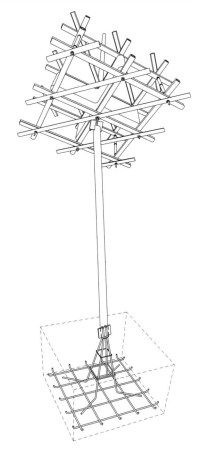

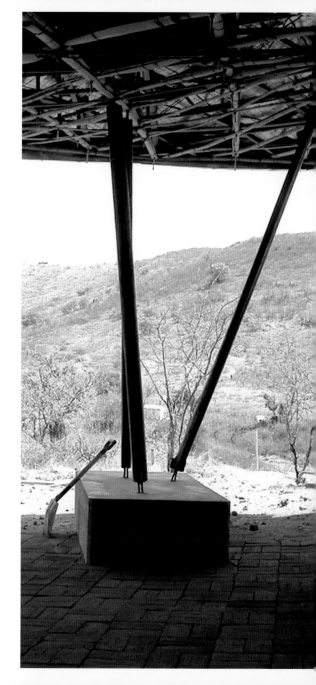

solar panel/ 330 kw/h
optimized positions towards the sun

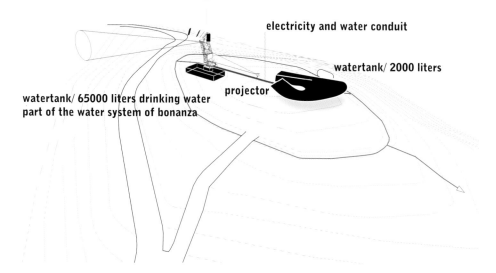

radio antenna

electricity and water conduit

watertank/ 2000 liters

projector

watertank/ 65000 liters drinking water
part of the water system of bonanza

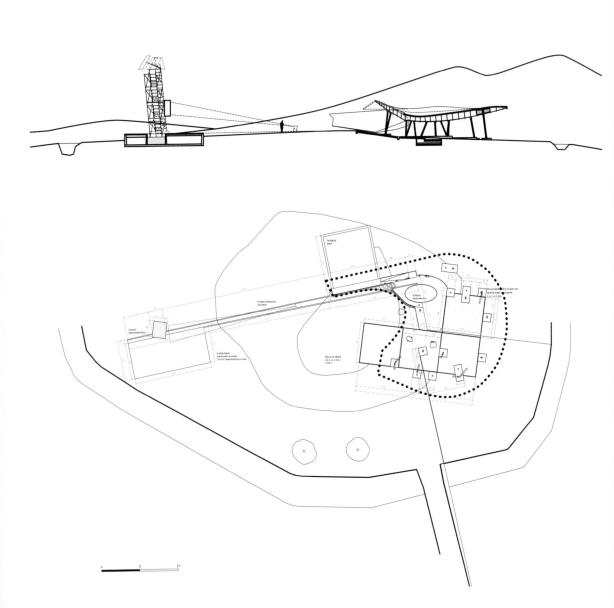

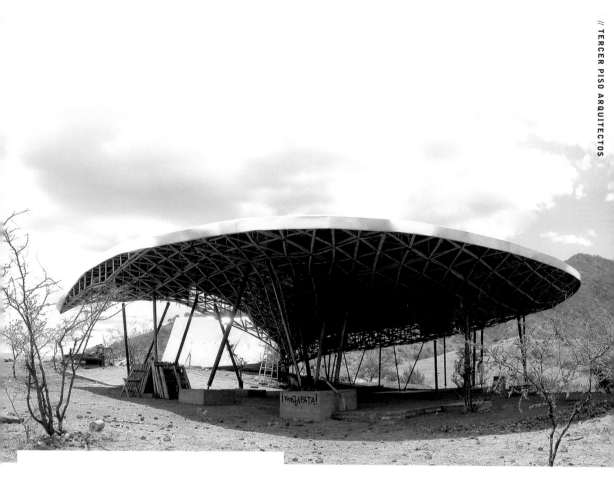

ARTEC Architekten

Raum Zita Kern, Raasdorf, Niederösterreich, 1996–1998

Eine Welt für sich am flachen Land vor Wien.

Zita Kern ist Bäuerin und Literaturwissenschaftlerin.

Arbeitsräume der Landwirtschaft sind vorhanden. Was fehlt ist ein Baderaum und Raum zum Schreiben.

Die alte Gebäudestruktur gibt den Rahmen vor:

Der Bereich der alten Kammer wird zum introvertierten Baderaum, die Entfernung einiger Balken schafft Lichteinfall von oben.

Das an- und aufgesetzte Bauvolumen gewinnt die Form aus den Randbedingungen: Öffnung zur Terrasse, Zugang und Aufgang ohne Eingriff in die Substanz und Überleitung der Figur zum kleinen Haus des Hühnerstalls.

Das Neue zeigt sich im Hofensemble als unzweideutig neu, der blanke Aluminiumkörper nimmt die Stimmung von Wetter und Umgebung auf.

Der Bau wird immateriell, sein Zweck undurchsichtig. Die Innenform des Neuen gleicht eher einem Zelt als einer festen Behausung.

Möblierung ist Teil der Wand und zugleich Strukturierungsmöglichkeit des Raumes. Lichteinfall und Öffnungen stehen mit dem Hof nicht in direkter Beziehung.

Apotheke zum Löwen von Aspern, Wien, 2002–2003

Durch einen geschlossenen Baublock wird der Raum als durchgängige, transparente Sequenz entwickelt.

Wie ein fliegender Teppich liegt über diesem offenen Raum eine weitgespannte Sichtbetondecke und bildet durch die aufgebogenen Enden den Abschluss zu den angrenzenden Straßen.

Höfe durchsetzen die Bausubstanz.

Der Verkaufsraum wird von „Lichtbändern" strukturiert, bündig eingelassen in die Decke.

Dort wo sie in den Raum ausbuchten, bilden sie Regale.

Haus Balic-Benzing, Bocksdorf, Burgenland, 2004–2005

Das südliche Burgenland ist eine sanft gewellte Hügellandschaft.

Der Baugrund zieht sich über eine Hangkuppe, mit Ausblick bis weit in die Steiermark.

Der Raumanspruch ist bescheiden:

Ein Raum für die Eigentümer (60 m²), ein kleinerer Raum für Gäste, getrennt durch einen Zwischenraum, der mit Schiebetüren reguliert werden kann. Fassung und Großzügigkeit schafft die Terrasse:

Zwei Ebenen, je 29 × 8 m, bilden Boden und Deckel. Die Terrassen bieten wettergeschützten Aufenthalt im Freien, abgehoben über dem Hang.

Efaflex Torsysteme, Baden, Niederösterreich, 2003–2004

Das neue Objekt landet mitten im Acker.

Der unspezifische Baugrund erlaubt, das Gebäude aus seinem Inhalt zu entwickeln:

Die Halle ist ebenerdig, der Bürobereich entwickelt sich vom großzügig überdeckten Zugang über einen Eingangsbereich mit Ausblick und Raum für Besprechungen hinauf in den oberen Stock.

Eine metallische Paneel-Haut umschließt den Baukörper, Bürobereich und Zugang werden durch flächenbündige Verglasung hervorgehoben.

Urs Bette

Uralla Court, Adelaide, Australien, 2003

Das „Lesen" der Auftraggeber und des Geländes führte zu einer innerlich definierten „Raumskulptur", die eine Lebensform und eine Art des Zusammenarbeitens skizziert, bei denen der Wahlmöglichkeit und der persönlichen Freiheit höchste Priorität beigemessen werden. Die Bewohner können zwischen verschiedenen Atmosphären, Wegen und räumlichen Situationen wählen, die den Grad der Interaktion oder der individuellen Konzentration auf die Arbeit bestimmen. Es gibt Bereiche, wo der Raum fließt und sich bewegt, und andere Bereiche, die stabil sind, wodurch unterschiedliche Absichten verwoben und verschieden-

artige Bewusstseins-Situationen geschaffen werden. Weite und Offenheit interagieren mit engen, schluchtartigen Aussparungen, extrovertierte Zonen mit schützenden Nischen und abgeschlossenen Einheiten. Das ganze Haus ist ein Tanz um den „Offenen Zufluchtsort". Die bestehende Landschaft bleibt im ganzen Projekt präsent; das Terrain findet sein „Echo" in den unterschiedlichen Ebenen, die durch das Innere des Hauses fließen. Arbeits- und Wohnbereiche kreieren zusammen einen Außenraum, der dem Bereich zwischen den zwei Gebäuden eine unerwartete urbane Qualität verleiht und den Block in private und öffentliche Sphären unterteilt. Die Strukturen bilden ein Paar, dessen bewusste Unabhängigkeit in einem topographischen und kulturellen Kontext das Resultat intensiver Auseinandersetzung mit dem Programm und den Charakteristika des Standorts ist.

Uralla Court II, Adelaide, Australien, 2005–

Der Neuentwurf von Uralla Court mit neuen Parametern: Die Reduktion des Volumens um zwei Drittel. Zuvor abgeschlossene Bereiche im Erdgeschoss werden nun als geschützte Außenräume genutzt. Die Stahl-Rahmen-Struktur sitzt auf einem unverkleideten Stahlbetonsockel. Dach und Fassaden sind belüftet. Die Fassaden sind mit Aluminiumblech verkleidet. Ein gewölbtes, verzinktes Stahldach sammelt das Regenwasser, das in einem örtlichen Tank gelagert wird. Ein Solarmodul für Heißwasser ist auf eines der Dachfenster gebaut.

The dragon in the sea, Okinotorishima, Japan, 2000

Die erodierende Insel Okinotorishima liegt am südlichsten Zipfel Japans im Südpazifischen Ozean. Bei Flut bleiben von der Insel nur zwei Felsen, drei und fünf Meter groß. Ohne diese Felsen würde das japanische Staatsgebiet bei der Insel Iwo-Jima enden, das Land würde so 400 000 Quadratkilometer Meeres-Territorium verlieren, mitsamt den dazugehörigen Fischereirechten und dem Rohstoffbesitz.
Jeder Taifun verkleinert die aus dem Wasser ragende Oberfläche der Felsen, daher beabsichtigt die japanische Regierung, 250 Mio. US-Dollar auszugeben, um die Insel zu schützen. Zentral ist, dass kein Element der unterstützenden Struktur die Insel berührt, da dies die Insel zu einem künstlichen Eiland ohne die Rechte einer exklusiven Wirtschaftszone machen würde.
„The dragon in the sea" ist die Choreographie eines jährlichen Rituals, das sich auf die vulkanische Herkunft der Insel stützt. Felsgestein vom Innern der Insel wird auf ihre Spitze geschmolzen, um das durch Erosion verlorene Material zu ersetzen. Dieses Ritual schützt die Insel für etwa 600 Jahre vor Rechtsstreitigkeiten.

The flat as answering machine, Wien, 1997

Jeder Mensch sammelt etwas, bewusst oder unbewusst. Es ist ein Impuls, ein Drang, etwas zu besitzen, aufzubewahren und nie wieder herzugeben. Sammeln ist ein Versuch, mit der Tatsache umzugehen, dass die Zeit vergeht und für immer verloren ist. Sammeln soll durch materielle Beweise Identität verkörpern im permanenten Vergehen der Zeit.
„The flat as answering machine" bewahrt Zeit und Atmosphäre auf. Während der Bewohner abwesend ist, sammelt die Wohnung, was vor sich geht; Geräusche, Licht, Geruch, Besucher, Wetter... Sie überbückt die Lücke zwischen dem auf Video aufgenommenen Familienanlass und der nicht zuhause erlebten Zeit.

DELUGAN MEISSL ASSOCIATED ARCHITECTS

Haus Ray 1, Wien, 2003

Ray 1, in der Dachlandschaft Wiens auf dem Flachdach eines Bürogebäudes aus den 60er-Jahren situiert, generiert sich zunächst aus diesem unmittelbaren Wirkungszusammenhang und der räumlichen Qualität dieses Ortes. Der Neubau entwickelt sich aus der Verbindung der beiden angrenzenden Gebäude, indem er die Giebellinie fortführt und gewissermaßen den missing link herstellt. Die Demarkationslinie zwischen Himmel und Erde wird hier jedoch nicht als

abschließende Trennung von Dach und umgebendem Kontext verstanden, sondern als durchlässige Grenze, die dabei selber zum Lebensraum wird. Durch Einschnitte und Überlagerungen werden transparente Bereiche und geschützte Terrassenlandschaften zu beiden Seiten des Gebäudes ausgebildet, die die exponierte Lage bis hin zum begehbaren Dach erlebbar machen. Die mit Alucobond beschichtete Außenhaut formuliert im Innenraum plastisch unterschiedliche Wertigkeiten verschiedener Zonen und Nischen, mit dem Ziel, die Möbel aus der Gebäudehülle heraus zu transformieren. Der Innenraum gestaltet sich als großzügiges Loft, dessen unterschiedliche Funktionsbereiche durch Auffaltungen und Höhendifferenzierungen definiert werden.

Filmmuseum Amsterdam, Niederlande, 2005

Das Thema „Film" als metaphorisches Erleben des Raums.
Es geht bei der Konzeption des Filmmuseums um das stimmige Zusammenwirken von Bau- und Filmkunst, des Raumbildenden und des Raumabbildenden in einer schlüssigen Verbindung. Licht ist ein wesentlicher Bestandteil der architektonischen Konzeption. Gleichermaßen wie das Licht als der chief architect dieses Baus gelten kann, wenn es auf der spiegelnden Glashaut ein fragmentiertes Bild wechselnder Tages- und Nachtstimmungen mit den unterschiedlichen

Schattierungen der Jahreszeiten entwirft, so ist es auch der chief director eines jeden Films.

Panoramalift Mönchsberg, Salzburg, 2003

Die Erschließung des Mönchsberg-Museums über den Panoramalift geht über den rein funktionalen Anspruch weit hinaus – vielmehr wird der spektakuläre Weg hinauf hier zum Ereignis, indem er nicht einer linearen Verbindung folgt, sondern sich aus der dem Berg folgenden Bewegung der Kabine vollzieht.
Diese wird – wie bei einer Langzeitbelichtung – in ihrem zeitlichen Gesamtablauf sichtbar und manifestiert sich als architektonisches Zeichen in der Verklammerung mit dem Mönchsberg.

Porsche Museum, Stuttgart, 2005

Mit dem neuen Porsche Museum wird ein Ort geschaffen, der der selbstbewussten Haltung des Unternehmens architektonisch Ausdruck verleiht und zugleich der Dynamik von Porsche Rechnung trägt.
Das Museum ist als losgelöster monolithischer Körper konzipiert, der über der gefalteten Topographie des Erdgeschossniveaus zu schweben scheint. Die weitläufige Arena des Ausstellungsraums verzichtet auf ein hierarchisches Ordnungsprinzip und das Aufzeigen einer linear vorgegebenen einzigen Zugangsweise: Querverweise werden offenbar und lassen sich in der

räumlichen und inhaltlichen Verknüpfung nachvollziehen.

the next ENTERprise architects

Seebad Kaltern, Caldaro/Kaltern, Italien, 2002–

Kopieren, Einfügen und Verschieben (Copy, Paste and Shift)
Die Freizeitwelten des 21. Jahrhunderts sind Fertigteilwelten – sie entstehen in der Regel aus der Synthese von optimierten Funktionsdiagrammen und narrativem Oberflächendesign. Beim Seebad verlassen the next ENTERprise den Weg des vorgefertigten Spektakels.
Ein Teil des Sees wird im Copy-and-Paste-Verfahren ans Ufer verpflanzt. Nicht nur die Oberfläche, die sich im Kräuseln der Textur des Betons wieder findet, sondern auch die räumlichen Tiefen des Sees mit seinen Unterwassertopografien formen den künstlichen Wasserkörper. Man kann die Perspektive eines Tauchers oder eines Schwimmers einnehmen, eines Fisches oder einer sich in die Wellen stürzenden Möwe, eines Surfers oder eines Promenadenflaneurs oder auch eines Theaterbesuchers, denn selbst die Seebühne wird in Form eines arenahaften Atriums mitverpflanzt. In dieser großzügigen mimetischen Geste wird der besondere Reiz des natürlichen Badesees aber nicht verdoppelt. Vielmehr reinszeniert der architektonische Seekörper die Spielarten der vorhandenen Wasserwelt und fügt der

Natur neue hinzu. Diese Aufführung von Natur ist immer schon künstlich und verweist damit auf den prekären Status unserer individuellen Körperwelten, die unwiderruflich medialisierte und inszenierte sind.
Angelika Fitz, April 2004

Freiluftpavillon im Schlosspark Grafenegg, Grafenegg, Österreich, 2005–

Die akustische Grundregel für eine Freiluftbühne „Wie man sieht, so hört man" war der Ausgangspunkt, um Affinitäten zwischen perspektivischem und akustischem Raum zu untersuchen. Eingebettet in die „Große Senke", die einen Panoramablick auf die historischen Gebäude bietet, greift der Pavillon Sichtbezüge zwischen diesen Gebäuden auf und platziert sich als ein weiterer „Landschaftsaufwurf im Park. Verschleiert durch die Reflexion von Wolken an der Metalloberfläche und eingebettet in die natürliche Mulde des Parks gibt sich die Gestalt der Freiluftbühne, je nach Tageszeit und Programm, unterschiedlich zu erkennen.

Nam June Paik Museum, Kiheung, Südkorea, 2003

Baugrund = Park / Park = Baugrund war die Prämisse, um das Gebäude als eine Fortführung der Freiräume, Pavillons und Verbindungspfade des Parks anzulegen: eine künstliche Insel, die mit dem Park auf verschiedenen Höhenniveaus verbunden ist.

Das Grundstück wurde über einen Verformungsprozess auf die vorgegebene Fläche von 1000 m² geschrumpft: dadurch wurden die Eigenschaften des natürlichen Geländes überzeichnet und verzerrt. Diese verformte künstliche Landschaft wurde mit dem Raumprogramm verschnitten und dadurch dem Gebäude eine künstliche Topographie eingepflanzt, aus der die Raumfolge entwickelt wurde.

Olienlöcher/Audiolounge, Installation für die Ausstellung „Trespassing – Konturen räumlichen Handelns", Secession, Wien, 2002

Die Audiolounge – der Beginn unserer Auseinandersetzung mit den von uns so genannten Olienräumen – ist eine Kugel mit computergenerierten Kraftfeldern, den „Sauglöchern", die sich als individuelle Hörräume definieren. Der Besucher wird durch das Murmeln angezogen und kann in die Löcher eintauchen. Die einzelnen Beiträge werden – ohne dass Kopfhörer benötigt werden – hörbar.
Die murmelnde „akustische Aura" und die räumliche Ausprägung involvieren den Zuhörer in ein akustisch spürbares Raumambiente. Die Fähigkeit, Besucher in einen entgrenzten, endlosen Tunnel „einzusaugen", in dem Innen und Außen, Oben und Unten aufgehoben werden, ist Ausgangspunkt für die weitere Beschäftigung mit Olienräumen.

Klaus Stattmann

Fluc_2, Wien, 2003–2006

In städtebaulich zentraler Lage am Wiener Praterstern werden eine Fußgängerunterführung und eine ehemalige öffentliche WC-Anlage zum Ausgangspunkt für das Veranstaltungslokal Fluc_2, nachdem der legendäre Musik- und Kunstklub Fluc_1 den Umbauarbeiten am Verkehrsknotenpunkt im Zuge der Fußball-EM weichen musste. Die Architektur der Ein- und Anbauten ist der performativen Praxis des Flucs verpflichtet, die von situativen Umgestaltungen geprägt wird. Ein Container-Ensemble wird von riffartigen Strukturen (siehe auch Riff Wien) besiedelt und mit Elementen von Eigenbau und Bricolage kombiniert. Unterhalb und entlang der 4-spurigen Stadtstraße entsteht ein „parcours accidental" aus lose aneinander gekoppelten „fluctuating rooms" mit differenzierten schalltechnischen Voraussetzungen, Bespielungssituationen und Umbaumöglichkeiten. Die dreidimensionale Kontingenz dieser „unaufgeräumten Lade" ordnet sich keinem Imperativ des Ganzen unter. Das Fluc_2 ist der materialisierte Beweis, dass Partizipation nicht durch pseudoneutrale Behälter angeregt wird, sondern durch ästhetische und strukturelle Differenziertheit; sofern sie sich als kontingente und partiell temporäre

Aufführung von räumlichen Zusammenhängen zu erkennen gibt.

Riff Wien, 1998/2003

Performativer Zwischenkörper entlang des Donaukanals, Länge: 1,3km
Nicht mehr Landschaft und noch nicht Architektur, gleicht das Riff Wien dem Zwischenwesen Korallenriff, dessen biologische Identität zwischen Tier und Pflanze angesiedelt ist. Als performativer Zwischenkörper oszilliert es zwischen topografischem Generator und Probebühne für wechselnde BenutzerInnen, die Konstruktionen einbauen, erweitern und wieder wegreißen.
In seiner räumlichen und zeitlichen Anreicherung des Baugrunds versteht sich das Riff Wien als Entgegnung auf die zunehmende „Vermanagung" des städtischen Raumes, als Plädoyer für heterogene Überlagerungen, nicht immer kontrollier- und planbar.

Haus Kinsky, Niederösterreich, 2000–

Das Grundstück an einem Nord-Süd-Hang des Wienerwaldes beinhaltet bereits ein Haus mit Obstgarten und ist ansonsten als Grünlandgebiet gewidmet. Das architektonische Konzept begegnet den Bestimmungen von Landschaftsschutz und Bauordnung mit einer performativen Transformation der Regeln. Das Haus bleibt in seiner Maßstäblichkeit erhalten, der Obstgarten wird durch eine bewohnbare Baumsphäre erweitert. Das neue Ensemble gliedert sich in drei Systeme:

das Alte Haus mit traditioneller Raumorganisation, die Baumsphäre als zu erobernde Landschaft und das Verschwundene Wohnzimmer zwischen Garten und Baumsphäre.

Zwischenraum, Mistelbach, Österreich, 2005

Eine performative Behausung für den Weinviertelfries „Gemischter Satz".
Der Zwischenraum dient als Behausung für den Weinviertelfries von Heinz Cibulka, eine 32 Meter lange digitale Collage über das Leben der Region. Das architektonische Konzept bezieht sich darauf, dass Pendler-Züge, die wie Strichcodes durch die Landschaft huschen, längst Teil des Landschaftsbildes geworden sind, ähnlich wie Strommasten oder Silotürme.
In Umkehrung zum passiven Zugpassagier geht der Betrachter beim Zwischenraum aktiv durch die Aufführungen von Landschaft, von den theatralischen Bildwelten des Frieses über die Stadtansicht von Mistelbach im Stirnfenster bis zum Horizont der Slowakei im Osten der Aussichtsterrasse.

stiefel kramer, vienna/zurich

„Promenade médiale – ein fortlaufendes Haus", Kunsthaus Graz, Österreich, 2000

Die Menschen in Graz sprechen von der „drüberen" Seite, wenn sie den Stadtteil westlich des Flusses Mur meinen. Auf jene „andere" Seite,

gegenüber der Altstadt und dem Schlossberg, soll das Kunsthaus zu stehen kommen.
Für die Stadt, für ein Haus der Kunst gilt es andere Räume, andere Wirklichkeiten zu entwerfen. Die Kunst ist eine eigene Wirklichkeit, ist weder Abbild noch Verdoppelung, ist nicht Kopie. Das Kunsthaus steht für Beobachtungsmaschine, Kunstverdauung, Produktionsstätte, Bühne, Wissenstransfer, Transitraum, es ist zugleich ein kontemplativer Ort. Dafür entwickeln wir ein „Raumprogramm der anderen Blicke", das sich nicht über die Quadratmeter der Bodenfläche definiert.
Mit der räumlichen Komposition unseres Kunsthauses, die geprägt ist vom Wechsel zwischen Stadt- und Innenraum, versuchen wir in städtebaulicher, programmatischer und funktionaler Hinsicht einen dialogischen Austausch zwischen der Realität der Stadt und der eigenen Wirklichkeit der Kunst zu etablieren. Der Museumsbesucher ist als bewegter Beobachter gewohnt, die Dinge immer auch in ihrer Veränderung durch das Wechseln von Standpunkten wahrzunehmen. Dadurch wird die ganze Stadt zum Kunstraum, zur Bezugsgröße für das Kunsthaus – und der Schlossberg wird Teil des Raumprogramms.

„Das fortlaufende Haus – ein Goyanisches Pferd", Diplomprojekt, Südaustralien, 1999/2000

Eine Studie über die Wandelbarkeit des physisch manifesten Raums am Beispiel eines öffentlich zugänglichen Hauses für einen Bildernarr und Wechseldenker. Durch die heuristische Wechselwirkung zwischen Beobachter, Beobachteten und Beobachtetem verlieren die Räume ihre statische Erscheinung und bauen sich fortlaufend neu auf. Ein spekulativer Versuch, im Rezeptionspotential von Architektur Entdeckungen der Quantenphysik zu etablieren, nach der sich ein Phänomen rein schon durch Beobachtung verändert.

das utopische moment / kann ja auch / in der form liegen / die bilder / hinter den bildern / assoziieren / goyanische schwärze / in die tiefe des raumes / wege für / beobachtete / beobachter / entwerfen / neue wirklichkeiten / fortlaufende häuser

Memento mori – Theater für Tragödien oder Wiener Kultur in Los Angeles, 1994/95

Stück in fünf Akten mit Vorspiel und Epilog

Städte lassen sich an ihrem (Hin-) Gang erkennen wie Menschen

Vorspiel: Das Thema

Erste Szene (Wien, Österreich)
Vom Untergang der k.u.k. Monarchie.
Zweite Szene (ebenda)
Von Herrn Freud und der Archäologie des Unbewussten.
Dritte Szene (ebenda)
Von der Gegenwärtigkeit von Morbidität in Literatur, Kunst und Wiener Alltag.

Erster Akt: Das Programm

Erste Szene
Theater als Stück und als Gebäude zur Inszenierung einer spezifisch wienerischen Stimmung und Atmosphäre.
Zweite Szene
Das Theater selbst als Tragödie.
Dritte Szene
Die Labilität des Systems.

Zweiter Akt: Der Ort, die Geologie

Erste Szene
(Los Angeles, California)
Das Unkontrollierbare und die mögliche Katastrophe als Voraussetzung.
Zweite Szene
(Hancock Park, Wilshire Blvd.)
Natürliches Teervorkommen. Ein teergefülltes, teichartiges Loch im Boden entlang des Boulevards.
Dritte Szene
Das trügerische Festland. Das Gebäude steht, schwimmt, sinkt und taucht in wechselnder Reihenfolge in der instabilen Umgebung des Teersumpfes.

Dritter Akt: Das Material

Erste Szene
Die schwarze, zähe, übelriechende Masse Teer.
Zweite Szene
Der ganze Komplex als geschlossenes, unter Druck stehendes System. Neoprenschlauch führt als Erschließung von der Schleuse ins Foyer.
Dritte Szene
Roher, schwerer Betonkörper (Auditorium) steht scheinbar fest am „Ufer", davon in den „Teich" wegkippender scharfkantiger, mit Stahlpaneelen verkleideter Stahlständerbau (Bühnenraum).
Vierte Szene
Neopren als Verbindung zwischen Beton und Stahl. Auf dem Dach des Betonbaus bildet sich eine pneumatische Hülle (Bar), ebenso auf der Seite gegenüber dem Eingang (Steh-Café). Bar und Café bilden in ihrer Weichheit und Farblichkeit den Gegenpol zu den schweren, harten Hauptbaukörpern.
Auftritt Licht, der Druck bleibt.
Fünfte Szene
Der öffentliche Weg führt durch das Foyer und den Orchestergraben über die Seitenbühne rauf zur Bar.

Vierter Akt: Die Zeit

Erste Szene
Die Bewegungen des Bühnenraumes werden mittels mechanischer Übersetzung auf die Bühne übertragen. Veränderungen des Raumes über lange Zeitspannen.
Zweite Szene
Bühnenraum kippt in den „Teich".
Dritte Szene
Zuschauerraum stanzt langsam das „Ufer" durch.
Vierte Szene ˙
Theoretisch gerechnet wird mit sieben bis zehn Jahren, bis das

Gebäude komplett abgetaucht ist. Das Theater ist zu jeder Zeit nutzbar und betriebstauglich.

Fünfter Akt: Das Erdbeben

Erste Szene

Zu erwartende Erdbeben können sowohl den errechneten zeitlichen als auch den prognostizierten Bewegungsablauf erheblich verändern.

Zweite Szene

Ein Erdbeben wird durch die mechanische Bühnenaufhängung sofort auf die Bühne übertragen und somit Teil der Inszenierung.

Dritte Szene

„The Big One" wird das letzte Stück inszenieren.

Epilog: Vom Wiener Hedonismus

Auch wenn das Theater versunken ist, schwimmt die Bar natürlich oben auf.

„Nasen" – Portale und Lüftergebäude für die zweite Röhre des Roppener Tunnels, Tirol, Österreich, 2005

Das Projekt „Nasen" setzt unsere Auseinandersetzung mit der Transformation urbaner und ländlicher Räume fort. In diesem Fall transformierten wir transitorische Orte (die Umgebung von Autobahntunnels) in neuartige Räume, deren Wahrnehmung und Nutzung sich je nach Entfernung, Geschwindigkeit, Art der Fortbewegung und Blickwinkel des Betrachters grundlegend verändert. Die „Nasen" umhüllen die Portale und Lüftergebäude eines Autobahntunnels in alpiner Umgebung. Statt nur eine Haut für die Lüftergebäude zu entwerfen, kreieren wir mit den „Nasen" begehbare Raumfolgen zwischen den verschiedenen Schalen einer mehrschichtigen Haut. Diese kontemplativen Räume treten auf eigenartige Weise in einen Austausch mit dem unwirtlichen, hochfrequentierten transitorischen Ort der Autobahn.

Wolfgang Tschapeller

BVA 1 2 3, Wien, 1998–2004

BVA 1. Die großen Stahlbetonskelettbauten nach einigen Jahrzehnten: Alles muss abgetragen werden; die Skelette aus Stahlbeton sollen jedoch bleiben. Ihre Lebensdauer übersteigt die der übrigen Gebäudeteile um bis zu 10 Perioden. Sie sind gewissermaßen das Gedächtnis von Gebäuden. So ein Skelett ist ein Grundstück, dreidimensional, und könnte theoretisch Ebene für Ebene (Zone für Zone) verkauft werden, dann wie Grundstücke Stück für Stück bebaut werden. Irgendwann werden keine Skelette mehr gebaut, da ohnehin überall Skelette verfügbar sind. Sie gehören niemandem. Gruppen von Siedlern spannen Häute über Skelette.

BVA 2. In bestehende Baumassen werden Hohlräume erodiert. Das Öffentliche drückt sich in das Private. Erosion ist ein Vorgang der Konstruktion. Erosion wird zum Prinzip des Städtebaus. Skelettkonstruktionen werden mit öffentlich nutzbaren und von außen zugänglichen Volumen bebaut. Die Skelette sind Grund, die Bebauungen formlos.

Guest rooms sind autark. Guest rooms sind ein Angebot des Baubestandes an die Öffentlichkeit. Es ist, als ob man hier eine Schale Reis für imaginäre Gottheiten aufstellt.

Guest rooms sind eine Art von Steuer. Guest rooms sind die luxuriösesten Räume in einer Stadt.

BVA 3. Die Versuchsanordnung dokumentiert Bewegungen in gebäudeähnlichen Geometrien, in Skeletten. Fremdkörper verursachen diese Bewegungen im Versuch, Skelette zu besiedeln. Beide, Skelett und Siedler, werden animiert. Sie können ihre Form, Dimension und Masse beschränkt verändern. Sie stehen in einem reaktiven Verhältnis zueinander.

Haus der Bildkunst, Bressanone, Italien, 2003

Das „Haus der Bildkunst" für einen Erzeuger von Bildherstellungs- und Bildbearbeitungsgeräten in Oberitalien wird technische Demonstrationsräume, Ausstellungsräume zur Dokumentation der Geschichte der Fotografie und ein Zukunftslabor für Bildforschung beinhalten. Es wird an einer Stelle des Tales gelagert sein, an der die großen Linien der überregionalen Infrastruktur – Autobahn, Eisenbahn und Staatsstraße –, an den Rand des

Tales gedrängt, den Berg am Fuß zerschneiden.

Das „entwickelte Format" – eine Zone von ca. 25 m × 25 m × 25 m – wird als assoziatives Konglomerat aus überregionalen, zufällig den Ort passierenden Elementen konstruiert. Es ist eine Konstruktion, die ähnlich wie Fotografie mit konstruierter Erinnerung operiert.

Theater an der Wien, Österreich, 2005–2007

Das Theater an der Wien hat für einen Ort, an dem Opern gespielt werden sollen, eine erstaunliche Positur. Es steht nicht sichtbar in der 2. Reihe. Die Baumasse ist gewaltig, und doch ist das Theater an der Wien als Objekt nicht vorhanden. Es wird von der anonymen urbanen Masse verschluckt. Sicher, das war nicht die Absicht der Erbauer. Wir dürfen vermuten, die Sache ist passiert.

Keine Vorfahrt, kein Vorraum – stattdessen ein Foyer, einem Nachbargebäude unterschoben wie ein junger Kuckuck: ein enger Raum, in den sich ein Portal wuchtet.

Diese Situation deutet auf die fahrigen Qualitäten dieser Zeiten hin.

Raumprogramme, Arien und Gesänge quellen aus ihren historischen Containern, fluten in den urbanen Raum, werden von Straßen zerschnitten, von kommerziellen Interessen gekappt, von Motorenlärm durchzeichnet. Und doch klingen Gesänge und Raumprogramme weiter.

Musiktheater Graz, Österreich, 1998

Für die Hochschule für Musik und Darstellende Kunst in Graz soll ein Haus für Musik und Musiktheater errichtet werden. Ein Projekt für ein Gebäude sollte im Rahmen eines 2-stufigen Wettbewerbs ermittelt werden. Wesentliche Raumvolumen sind ein großer Saal mit ca. 500 m² Fläche und 10 m Höhe, große Proberäume für Orchester und Musiktheater sowie Foyerräume. Der vorliegende Projektvorschlag geht von einer extremen Modulation, auch Erosion der Grundstücksfläche aus. Diese Erosion der Grundstücksoberfläche soll so formuliert sein, dass die funktionalen und programmatischen Vorgaben des Nutzers möglich sind. Ich sage: möglich sind, weil ich denke, dass das Verhältnis von Raum und dem, was in diesem Raum geschehen soll, ein größeres Maß an Ambivalenz benötigt. Ich denke daran, dass eine Wiese nicht zum Liegen und Schlafen gemacht ist, trotzdem ist es ein vortrefflicher Ort zum Schlafen.

Sophie Grell

Raum oder Vorfeld, Wien, 2004–2005

Die vorgeschlagene Struktur schreibt sich in die Sequenz von Tordurchgängen ein, die, vom Michaelerplatz bis zum Vorplatz des Wiener MuseumsQuartiers, Stadträume mit dem menschlichen Maßstab in

Beziehung setzen. Diese Möglichkeit, Geschichte unmittelbar zu erleben, bricht vor dem MuseumsQuartier ab. Die Veränderungen im Inneren des Komplexes sind außen nicht spürbar. Sie treten nicht auf. Das in vier Elemente aufgelöste Dach artikuliert die Spannung zwischen Kontinuität und Autonomie und synkopiert den Rhythmus der Barockfassade. Zwischen Dach und Außenfassade entsteht ein zweiter Raum. Sowohl Innen- als auch Aussenkanten des Daches sind Informations-Trajektoren, die auf spezifische Weise den verschiedenen darauf bezogenen Rezeptionsarten Rechnung tragen. Unter dem ersten Element des Daches befindet sich eine sockelartig erhöhte Zone, die im Zusammenhang mit den bespielbaren Dachkanten für verschiedene Funktionen wie Open-Air-Kino, Ausstellungsfläche, Freiluftbüro, Chillout-Zone, Clubbing, Eislaufplatz genutzt werden kann.

Das Dach verdichtet sich elastisch zu einem Turm, der im Denkmal Maria Theresias eine maßstäbliche Entsprechung hat und im Flakturm seinen städtebaulichen Bezug findet. Er emittiert seine Energie in einem Lichtkegel. Unter dem Lichtkegel des Turmes befindet sich eine Freiluftbühne, in der weiteren Nutzung eventuell ein Informationspavillon.

Infokörper und Wegweiser unter dem Dach und auf dem Platz geben den Informationen der einzelnen Institutionen innerhalb des MuseumsQuartiers

Profil und sind auf deren jeweilige Position ausgerichtet. Bei Eröffnungen und anderen Events werden sie auf den entsprechenden Eingang des Museums-Quartiers gerichtet.

Tercer Piso Arquitectos

Techo en Mexico, Oaxaca, Mexico, 2002–2004

Techo en Mexico ist die physische Auseinandersetzung mit der Figur des Daches als archetypische Form der Architektur, basierend auf einem Entwurfsprojekt, das im Sommersemester 2003 im Studio von Prof. Wolf D. Prix an der Universität für Angewandte Kunst Wien begann. Das Dach als offene Art der Raumabgrenzung genügt den Minimalerfordernissen nach Sonnen- und Regenschutz und schafft eine kritische Beziehung mit der Landschaft, von der es sich weitgehend löst.

Die Rolle des Umrisses ist, dem unstabilen Gleichgewicht zwischen dem Raum und seiner Peripherie ein Maß zu geben.

Die Linie der Traufe beschreibt eine dreidimensional verformte Höhenschichtlinie, die mit den bestehenden, auf den Boden gezogenen Zeichen ein neues Bild generiert: eine Inszenierung des Wassers.

Das Wasser wird in einer Rinne sichtbar über das Gelände zu einem Speicher geführt. Dieser bildet das Fundament für den Lichtturm, der dem ganzen Tal zum Bezugspunkt wird.

Photo credits/Bildnachweis

BUNDESKANZLERAMT ■ KUNST
www.art.austria.gv.at

University of Applied Arts Vienna
INSTITUTE OF ARCHITECTURE

Studio Zaha Hadid
Studio Greg Lynn
Studio Wolf D. Prix

The continuous necessity of re-defining architecture both in theoretical and practical terms should be the main focus of teaching: Design as an all inclusive thought process that puts the future architect in the position to define architecture as a three-dimensional expression of culture. This is the goal of the Institute of Architecture at the University of Applied Arts Vienna.

In order to achieve this, studios closely work together with the specialists in technology, theory, and editing in our Institute.
This potential for interaction, in connection with the comparatively small number of students facilitates the transfer of knowledge by means of small, networked teams. In computerlabs and state-of-the-art model shops the latest technologies are tested in theory and practice.
The Experimentarium, a combination of design studio and technical laboratory, permits to intensely pursue large-scale research projects. Besides these new media, the material implementation and development of spatial ideas in physical models play a major role in the studios. Only the simultaneity of different systems allows creative potential to unfold, unhindered by premature specialization.

Exchange programs with British (Bartlett School of Architecture) and American universities (Columbia University, UCLA, SCI-Arc, University of Houston) give students the chance to see beyond the horizon.

CONTACT
Institute of Architecture
University of Applied Arts Vienna
Oskar-Kokoschka-Platz 2
A-1010 Vienna, Austria

T +43 (1) 71133-2331
F +43 (1) 71133-2339

architecture@uni-ak.ac.at
www.dieangewandte.at/architecture

Klaus Bollinger—Structures
Ernst Maczek-Mateovics—Building Construction
Roland Burgard—Technical Installations
Liane Lefaivre—History and Theory of Architecture

dı:'ʌngewʌndtə

University of Applied Arts Vienna
URBAN STRATEGIES
Postgraduate Program

Since fall 2005, the University of Applied Arts, Vienna offers a three-semester postgraduate program under the auspices of the three professors of the Institute of Architecture—Zaha Hadid, Greg Lynn and Wolf D. Prix—leading to a Master of Science in URBAN STRATEGIES.

In six intensive eight-day seminars (=modules; two modules per semester) the latest innovations in urban strategies will be analyzed and improved upon step-by-step. To facilitate a multifarious dialogue between teachers and participants, the modules will be held by guest-professors and cutting-edge architects from well-known institutions from all over the world.

Each program will have its own "Theme of the year," which will be covered in lectures, discussion panels and workshops in team-oriented, small-sized groups. Further, each guest lecturer will present an individual topic within the framework of the Theme, which will be investigated by the participants by carrying out short assignments and projects. By means of the "Theme of the year," urban strategies will be analyzed and theoretically dealt with, in order to develop solutions and design concepts. Workshops will give participants the chance to discuss and evaluate the progress of their projects with the guest lecturers.

The thesis project, which will be presented and discussed at a final event, will commence the program.

Head of program Wolf D. Prix and his assistants will be introducing the participants to the subject matter and further mentor the participants throughout the program. The guest instructors will contribute the various topics, which will be relevant to the "Theme of the year."

CONTACT
Urban Strategies
Postgraduate Program
University of Applied Arts Vienna
Oskar-Kokoschka-Platz 2
A-1010 Vienna, Austria

T (+43 1) 71133-2336
F (+43 1) 71133-2339

urban.strategies@uni-ak.ac.at
www.dieangewandte.at/archurban

Tentative Guests Raimund Abraham, Charles Correa, Mario Coyula-Cowley, Peter Eisenman, Jeffrey Kipnis, Thom Mayne, Eric Owen Moss, Patrik Schumacher

Admisssion Degree in Architecture or Landscape-Architecture
Beginning every Semester
Duration 3 Semester, 2 Modules per semester each 8 days
Degree Master of Science (MSc)
Fees EURO 15.000,-

di: 'ʌŋgewʌndtə